IMAGES
of America

PITTSFIELD

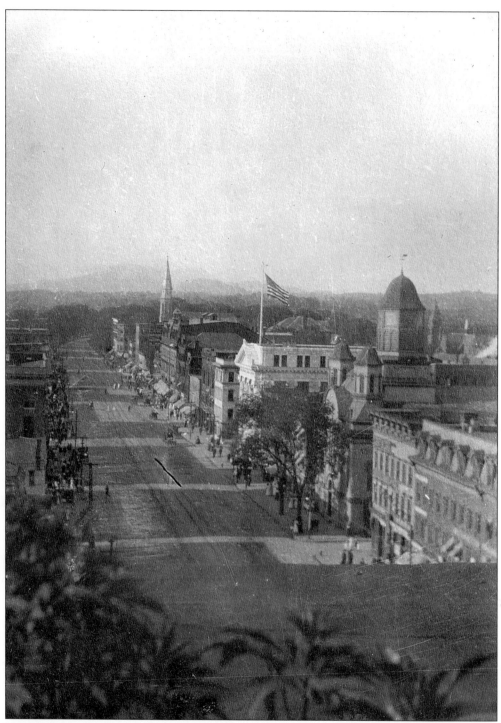

NORTH STREET FROM THE ROOF OF THE WENDELL HOTEL, C. 1910. The Wendell Hotel was a favorite spot for photographers, both amateur and professional, to get panoramic views of the city and surrounding countryside. This photographer took four pictures from the same spot, looking north, south, east, and west.

IMAGES
of America

PITTSFIELD

The Berkshire County Historical Society

ARCADIA

First printed in 2001.

Published by Arcadia Publishing,
an imprint of Tempus Publishing, Inc.
2A Cumberland Street
Charleston, SC 29401

Printed in Great Britain.

Library of Congress Catalog Card Number: 2001092557

For all general information contact Arcadia Publishing at:
Telephone 843-853-2070
Fax 843-853-0044
E-Mail sales@arcadiapublishing.com

For customer service and orders:
Toll-Free 1-888-313-2665

Visit us on the internet at http://www.arcadiapublishing.com

*This volume is dedicated to all the priceless volunteers who
make the work of the Berkshire County Historical Society possible.*

CONTENTS

ACKNOWLEDGMENTS

Many, many thanks go to Maida Henriques and Norma Purdy, volunteers extraordinaire who helped with much of the research for the captions. Thanks also to the many donors who made these photographs a part of the collections of the Berkshire County Historical Society, where they will provide future generations with a glimpse into the past. Thanks go to the Berkshire Athenaeum for allowing us to publish their wonderful portrait of Herman Melville. In addition, thank you to Arcadia Publishing for making these images available to everyone.

INTRODUCTION

Pittsfield can be an enigma. The largest and most industrial town in a county that prides itself on being "America's Premier Cultural Resort," it has a personality that sets it quite apart from other towns. When you look closely, Pittsfield has contributed every bit as much to culture, beauty, grandeur, compassion, invention, and humor as any town in the Berkshires. Without the heartbeat of the city, the county would be so much less than the wonderful place it is today.

Although not the first settled town in the Berkshires, Pittsfield grew more rapidly, taking advantage of a central location and an entrepreneurial spirit to push itself along. Its location in a low spot among the hills helped make it an ideal choice for the railroad, for which Pittsfield lobbied ardently. Pittsfield also lobbied ardently for decades to be the county seat. Raising its first petition in 1812, Pittsfield (after numerous attempts and numerous defeats) finally won in 1868 at the cost of having to build a new courthouse and a new jail.

Pittsfield has contributed more than its share to the American cultural scene. Oliver Wendell Holmes wrote numerous poems here drawing on the natural beauty that surrounded his home at Canoe Meadows for inspiration. Herman Melville was so inspired by the view of Mount Greylock from his uncle's home on South Street that he bought a house he could not afford next door just so he could gaze at Greylock while he wrote. The first thing he completed here was no small feat—*Moby-Dick*, a book that reflects the Berkshires as much as it does the sea. As Melville himself wrote in a poem about his barn at Arrowhead, "For a spirit inhabits, a fellowly one / The like of which never responded to me / From the long hills and hollows that make up the sea / Hills and hollows where echo is none."

Literature was not Pittsfield's only contribution. Elizabeth Sprague Coolidge, who built a magnificent summer home here, established the South Mountain Chamber Concert series. A composer and patron of the arts, she nurtured the Berkshires' role as musical inspiration before the establishment of Tanglewood. Pittsfield's Colonial Theater brought the highest-quality professional theater to the area in the early 20th century.

The Colonial also highlights Pittsfield's role as a canvas on which some of America's finest architecture was painted. Charles Bulfinch designed the Second Meeting House in 1793, a structure that was unfortunately lost in 1939. The Berkshire cottagers did not shun Pittsfield, with upwards of a dozen spectacular summer residences built in town. The enormous Victorian homes of the prominent industrialists of the town were also fine examples of American architecture. Pittsfield boasts one of only 300 or so octagonal houses built in the United States in the 19th century.

The industrialists were the men who profited most from the hard work and ingenuity of Pittsfield's citizens. Arthur Scholfield, an Englishman who produced the first wool-carding machine in the United States, moved to Pittsfield in 1800 to start his successful business that transformed American cloth manufacture. William Stanley, a Great Barrington resident when he invented the alternating current electrical transformer, moved to Pittsfield to continue his innovative work, which General Electric eventually put to work for them. Pittsfield was the site of the first man-made lightning, an innovation that allowed for better testing of electrical equipment and for safety improvements.

Pittsfielders have always been compassionate neighbors. During the War of 1812, they were so kind to the British officers who were prisoners of war that the officers became a major part of the Pittsfield social scene, attending balls and parties and roaming around town at will so long as they promised to return home at night. The Berkshire Agricultural Society, the first in the United States to hold a county fair, was open to men and women at all economic levels. It was an organization that was genuinely interested in improving the lot of all farmers, not just those who could be called "gentlemen."

Pittsfield's natural beauty is surpassed nowhere in the county. With its two large lakes, Pontoosuc and Onota (Pittsfield shares Pontoosuc with its neighbor, Lanesborough), and its spectacular vantage point of Mount Greylock, Pittsfield is tailor-made for the photographer. Canoe Meadows Sanctuary and Pittsfield State Forest provide quiet experiences with nature. The Shakers chose Pittsfield as a site worthy of creating a paradise on earth.

This book focuses on the past because it is the Berkshire County Historical Society's mission to do so. However, there are good reasons to focus on what has gone before. The value of history is many-fold. History not only allows us to examine our mistakes so that we do not repeat them, but it provides us with countless examples to inspire us to do better and to remind us of what we are capable of doing. The study of history reminds us that one person, one neighborhood, or one town can make an enormous difference in the world.

The photographs in this book take us up to World War II, although a few photographs slip past that era. All but one of the photographs come from the collections of the Berkshire County Historical Society, located in Pittsfield. The society's photographic collection includes more than 14,000 photographs, ranging from daguerreotypes to Polaroids, and more than 11,000 postcards documenting the last 160 years of life in Berkshire County. The Margaret H. Hall Library and Archives also includes more than 500 linear feet of manuscript collections, prints, and maps that take that history back even further to 1740.

We are delighted to have this opportunity to share our collections with you. As you are taking your own pictures and filling your own photograph albums, think of the contribution your pictures might make to the lives of those who come after you. Photographs of the past educate, inspire, and entertain us.

—Susan Eisley
Executive Director

One

PONTOOSUCK
TO PITTSFIELD

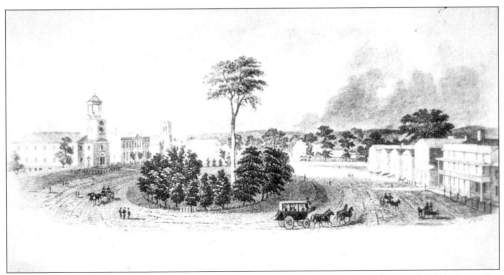

PARK SQUARE, 1832. This romantic view of Park Square shows the early Pittsfield skyline. On the left are the Second Meeting House, the second town hall, and St. Stephen's Episcopal Church. On the right are the buildings of Bank Row and the Pittsfield Female Academy.

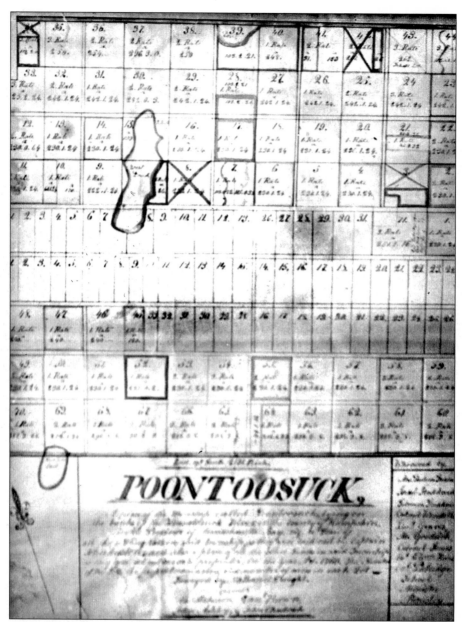

PLAN OF POONTOOSUCK, 1760. Taxes were the motivation for the founding of Pittsfield. In 1735, the City of Boston, complaining that its tax burden was unfair, petitioned the general court for a grant of lands in western Massachusetts that it could then resell to earn revenue. Since there was a border dispute between Massachusetts and New York over control of the region, Boston was anxious to promote settlement to solidify its claims to the land. Boston established three townships in the area and, in 1726, sold the one that was to become Pittsfield to Jacob Wendell of Boston. Wendell had the land surveyed, laid out two roads (the roads that form North, South, East, and West Streets), and created 60 lots for sale. Called Pontoosuck Plantation, the settlement took its name from the Mohegan name for the area, meaning "land of the winter deer." This map shows the settlement as it looked in 1760, one year before it was incorporated as a town and renamed Pittsfield in honor of British statesman William Pitt.

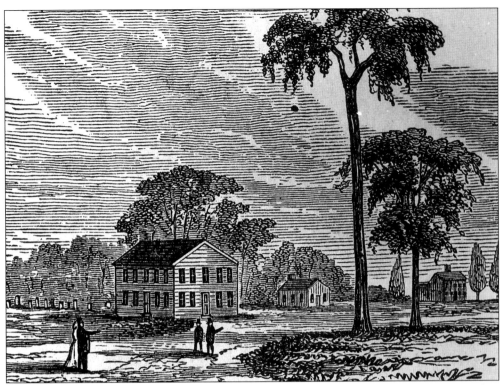

CENTRAL PITTSFIELD, C. 1770. The Pittsfield elm stands above all else with the town's first three public buildings surrounding it. By law, every town in Massachusetts was required to provide schooling for its children along with a Congregational church and parsonage. From left to right are the first meetinghouse, the school, and the parsonage. The school was one of three built in 1764, when the population of Pittsfield was approximately 700.

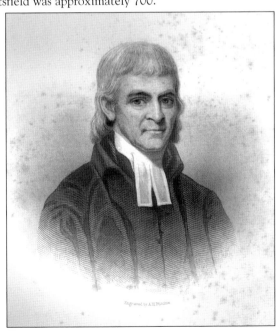

REV. THOMAS ALLEN. Known as the "Fighting Parson" for his leadership during the American Revolution, Thomas Allen provided spiritual leadership to the town as well. Between 1759 and 1764, Pittsfield had four ministers, none of whom was satisfactory to town leadership. Finally, in 1764, the town chose Thomas Allen of Northampton. Only 21 years old at the time, Allen remained at his post until his death in 1810.

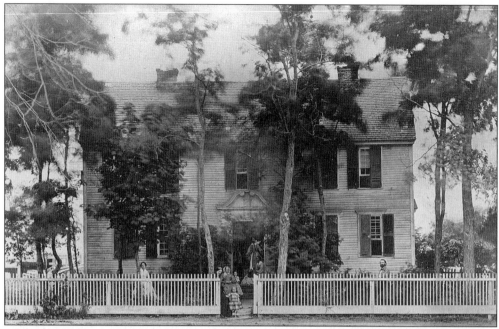

THE PARSONAGE, C. 1860. The original parsonage, built in 1764, was eventually replaced with this one, which also housed Reverend Allen's son, Rev. William Allen. The property was later purchased by Parson Allen's grandson and namesake, Thomas Allen, who built his summer home on the site.

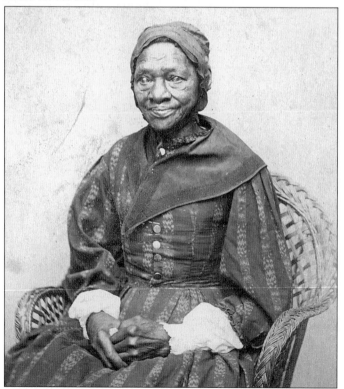

PENDAR, C. 1855. This photograph comes from a stereo card. Labeled "No. 2 Negro Woman Pender," it was part of a set of views of Pittsfield. Pendar, who lived to a grand old age, had been a slave of Col. William Williams, a prominent citizen in early Pittsfield history. Glued to the back of the card is a facsimile of Williams's receipt, dated November 7, 1761, for her purchase from William Day of Westfield.

THE PEACE PARTY HOUSE. Col. James Easton built another local landmark, the Peace Party House, in 1776. The house was originally situated on the southwest corner of Wendell Avenue and East Street. Purchased during the Revolution by John Chandler Williams, it was the site of Pittsfield's grand celebration of the signing of the Treaty of Paris in 1783, which ended the Revolutionary War. Williams's wife, Lucretia, was the daughter of Col. Israel Williams, a Tory leader in Pittsfield. Lucretia remained loyal to the British after the war, even though her husband was an ardent supporter of American independence. She was nevertheless a gracious host during the celebration. In 1869, to make way for the new county courthouse, the Peace Party House was moved to the southeast corner of Wendell and East, where it remained until it was torn down in 1957 to make way for a new library, which was not built until 1975. (Photograph by William Tague.)

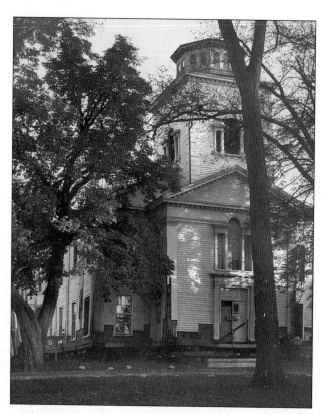

THE BULFINCH CHURCH, 1938. Built in 1793 on the same site as the original meetinghouse, the Second Meeting House was designed by renowned architect Charles Bulfinch, designer of the U.S. Capitol and Faneuil Hall. It was damaged by fire in 1851 and moved to the Pittsfield Young Ladies Institute, where it was converted to a gymnasium, later becoming part of the Maplewood Hotel until the church was torn down in 1939. (Photograph by Margaret Stanley.)

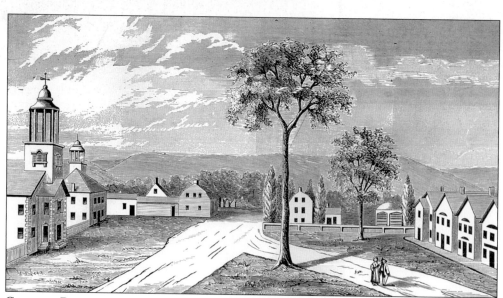

CENTRAL PITTSFIELD, 1807. This engraving shows the Second Meeting House on the left, with the first Pittsfield Town Hall, also built in 1793, next to it. In 1810, the space under the elm was the site of the very first agricultural fair held in America, organized by Elkanah Watson, founder of the Berkshire Agricultural Society. This was the first such society open to working farmers and to women, not just to gentlemen farmers.

14

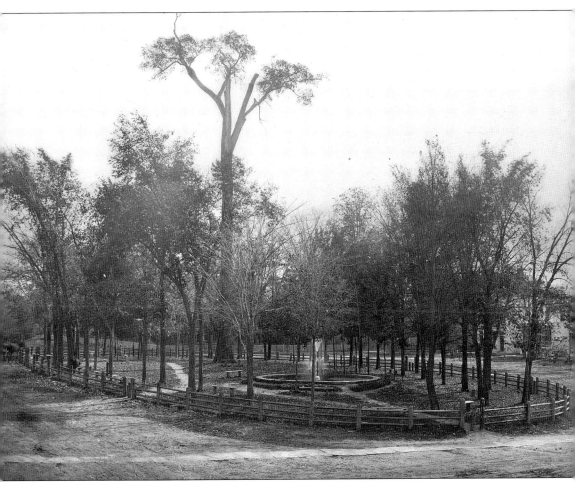

PARK SQUARE, 1855. When the Second Meeting House was built in 1793, it had been decided to cut down the elm to provide needed space. Lucretia Williams protested vehemently, hanging on to the tree and refusing to move for the axmen. The problem was solved by her husband, who arranged to have the church built a little farther north in exchange for the donation of land just to the south of the tree to be used as common space. It was many years, however, before the familiar elliptical shape of Park Square appeared. In 1825, led by Edward A. Newton (the Williamses' son-in-law), a citizens' committee fenced in the area and laid out the roads around it, also planting the trees. In 1829, Pittsfield's first public sidewalks were created around the park. The elm was taken down in 1863 when it could no longer sustain life.

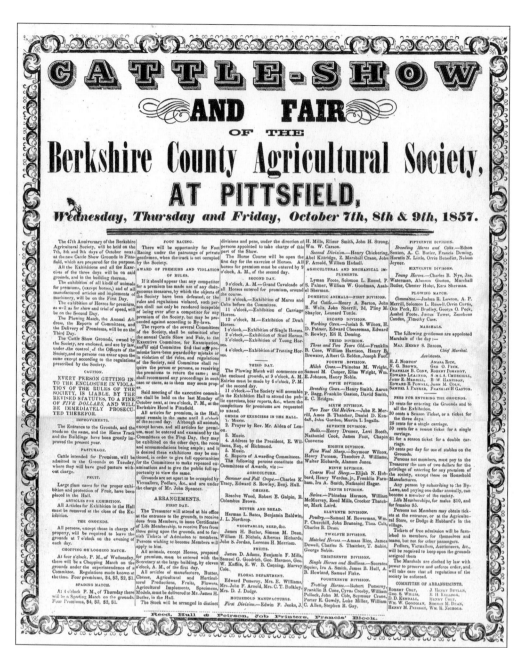

A BROADSIDE, BERKSHIRE CATTLE SHOW, 1857. The Berkshire Cattle Show of 1810, organized by the Berkshire Agricultural Society, was the first county fair held in the United States. The purpose of the society was to promote innovation in local agriculture by providing information to area farmers. The fair's mission was to recognize the achievements of area farmers by awarding prizes for their work. The society was active for nearly 100 years, but as the town's economy moved toward manufacturing, the character of the fair changed from a competition designed to promote advances in local agriculture to an advertisement for manufactured goods, and the society decided to end the fair in 1901. The society itself disbanded that year.

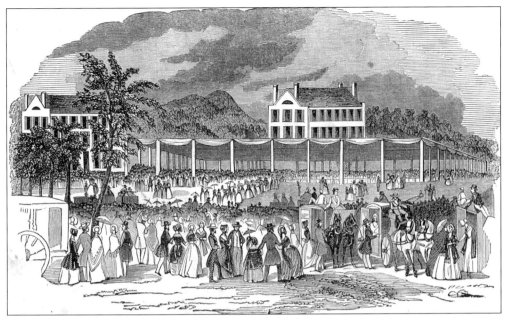

THE BERKSHIRE JUBILEE, 1844. In 1844, Pittsfield hosted a homecoming celebration for all of Berkshire County. More than 3,000 people attended the event, which began in the morning with speeches and presentations held at the home of Dr. Timothy Childs. In the afternoon, the crowd removed to the grounds of the Pittsfield Young Ladies Institute for a banquet. So impressive was the occasion that it even received publicity in the *London Illustrated News*.

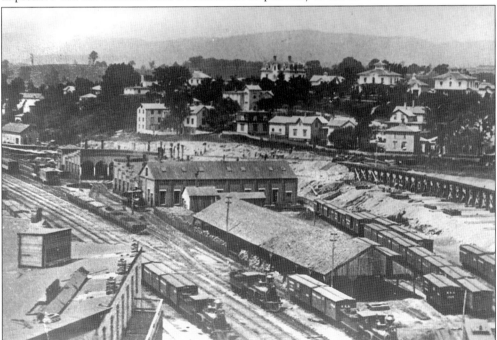

JUBILEE HILL, C. 1870. The area where Timothy Childs's residence was located has been known ever since as Jubilee Hill. This photograph shows the hill with its many fine houses. The railroad yards, begun in 1841, are seen in the foreground.

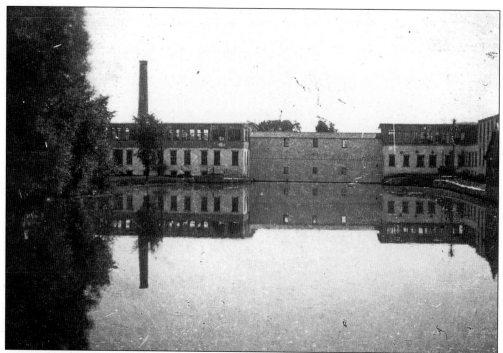

POMEROY MILLS, C. 1890. In 1800, an enterprising Englishman named Arthur Scholfield moved from Connecticut to Pittsfield, bringing with him the first wool-carding machine ever known in the United States. In 1814, Lemuel Pomeroy bought Scholfield's factory and established the Pittsfield Woolen and Cotton Factory, which remained in operation until 1893. It was the first successful mill of the many that were to be built in the town in the 19th century.

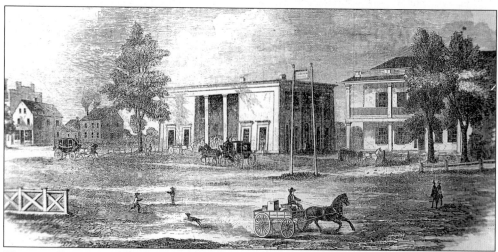

WESTERN RAILROAD DEPOT, C. 1842. This engraving shows Pittsfield's first railroad station, built in 1841. The Boston & Worcester Railroad had been organized in 1831, but the Western Railroad did not reach Pittsfield until 1841. Pittsfield had lobbied diligently for the railroad to help its burgeoning industries. Most residents agreed that when this "Egyptian-style" station was destroyed by fire in 1854, it was for the best.

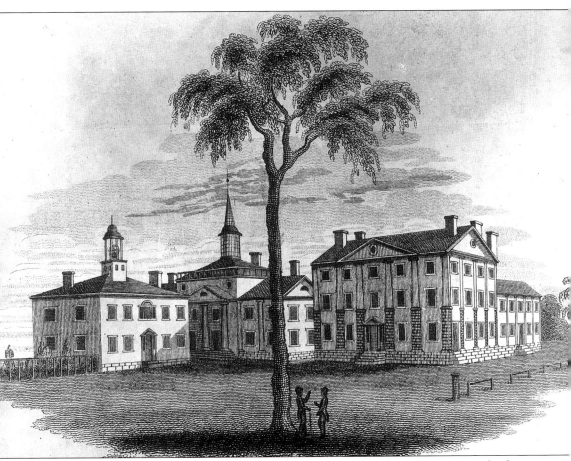

BERKSHIRE MEDICAL INSTITUTION, C. 1830. Established in 1823, the institution was the first medical school in western Massachusetts. Located off Park Square, in the old Pittsfield Hotel, there were concerns expressed by town folk about its proximity to the town cemetery. The year before had witnessed a grave-robbing incident, and citizens were worried that those buried there might be subject to abduction by medical students for the purpose of dissection. The school managed to calm the public's fears and, by 1824, the college had converted the hotel's stables into a classroom building with the old hotel serving as a dormitory. This engraving shows the town hall, the institute, and the dormitory. The original building burned in 1851, and the institution built a new building on South Street, where it remained until its closing in 1869. The building was then sold to the town, which converted it into a school in 1871. In its 44-year existence, it graduated 1,138 doctors.

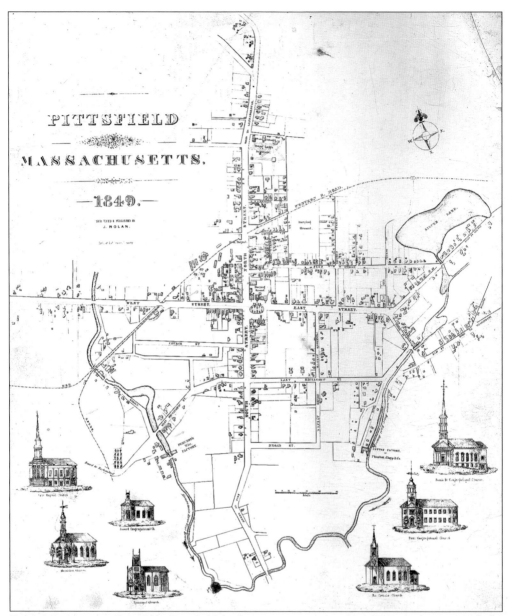

PITTSFIELD, 1849. By 1849, Pittsfield had grown into a bustling industrial town and the commercial center of the Berkshires with a population of more than 7,000. In addition to the textile mills, Pittsfield had one paper mill, a steam engine factory, a millstone maker, and a quarry. The town also had businesses that made hats, brooms, trunks, carriages, soap, tinware, and silverware.

Two

The Heart of the Berkshires

THE HOUSATONIC RIVER, C. 1910. The river provided a source of power to fuel the town's expanding industries, but the Housatonic is also a source of great beauty.

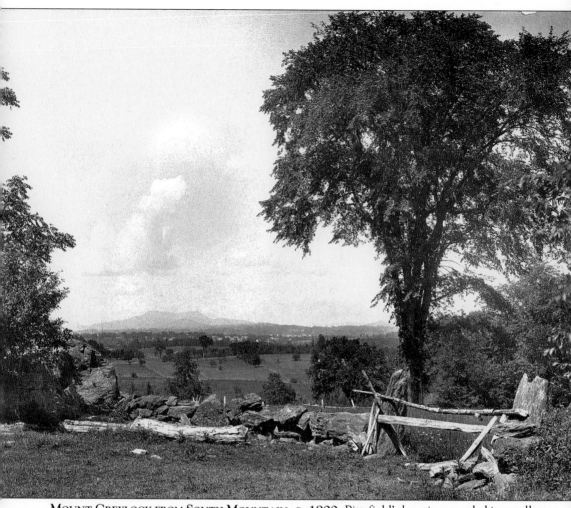

MOUNT GREYLOCK FROM SOUTH MOUNTAIN, C. 1900. Pittsfield's location, nestled in a valley among the Berkshire Hills, makes it one of the loveliest cities in the eastern United States. This photograph was taken by noted photographer Edwin Hale Lincoln and shows Mount Greylock, the tallest point in Massachusetts, as it rises up over the city.

PONTOOSUC LAKE, 1913. Laura Cowles, a talented amateur photographer, took this spectacular photograph of lightning over Pontoosuc Lake before the advent of high-speed film.

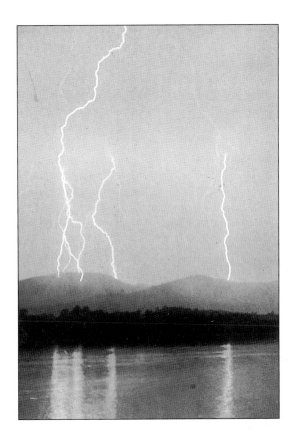

A NOVEMBER LANDSCAPE, 1914. Laura Cowles's photograph album contains numerous urban and rural landscapes, along with portraits, candid shots of family and friends, and photographic records of important places and events. (Photograph by Laura Cowles.)

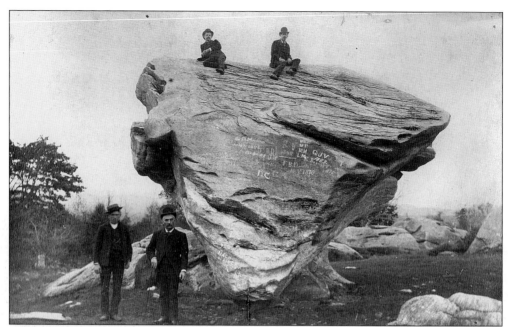

BALANCE ROCK, 1890s. Balance Rock has been a tourist attraction since the early 1800s. Although located in the town of Lanesborough, it was purchased by the Balance Rock Trust and conveyed to the City of Pittsfield in 1916. Now part of Pittsfield State Forest, the rock has been the subject of many photographs, and Herman Melville featured it in his novel *Pierre*, written in Pittsfield in 1852. (Photograph by W.E. Day.)

AN EARLY-WINTER LANDSCAPE. This scene was captured in the western part of Pittsfield.

24

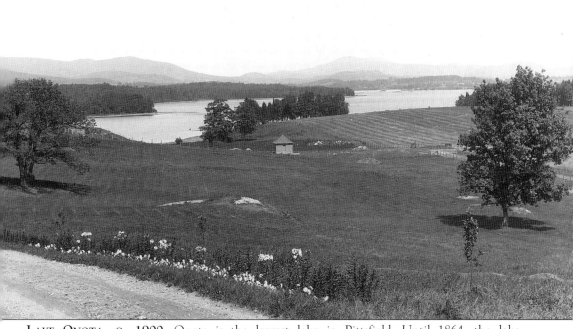

LAKE ONOTA, C. 1900. Onota is the largest lake in Pittsfield. Until 1864, the lake encompassed 486 acres and was divided into two distinct sections by a beaver dam. This division was removed when the water level was increased in 1864 and the acreage enlarged to 683. Many beautiful homes were built on its shores, and it is now a popular recreational spot with Burbank Park located at its edge. (Photograph by Edwin Hale Lincoln.)

THE WOODS AT ALLENDALE, C. 1900. This late-winter portrait was taken by Edwin Hale Lincoln, known for his spectacular landscapes of the Berkshires as well as his formal portraits of the houses of Newport, Rhode Island. Lincoln had been a drummer boy during the Civil War and was active in the Pittsfield Grand Army of the Republic (GAR), a Civil War veterans' organization.

SNOWSHOE TRACKS, C. 1940. Forty years later, Arthur Palme captured a similar scene. Born in Austria, Palme came to the United States just before World War I and took a job with General Electric. He took up photography in order to document the beauty of the natural world around him. An early pioneer in the use of high-speed photography, he was elected a member of the Royal Photographic Society of Great Britain in 1949.

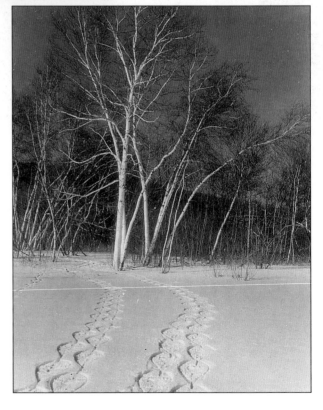

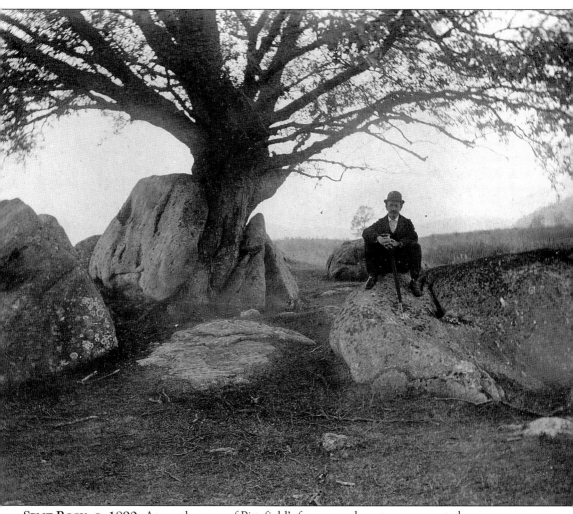

Split Rock, c. 1890. At another one of Pittsfield's famous rocks, a tree appears to have grown through solid stone.

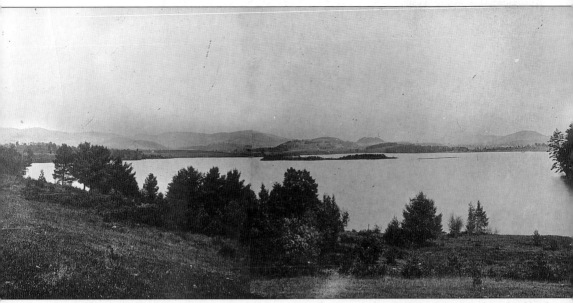

PONTOOSUC LAKE, C. 1878. Like Onota, Pontoosuc was carved by glaciers hundreds of thousands of years ago. A favorite destination of early Native American hunters because of the abundant deer, Pontoosuc now provides recreation as well as scenic beauty.

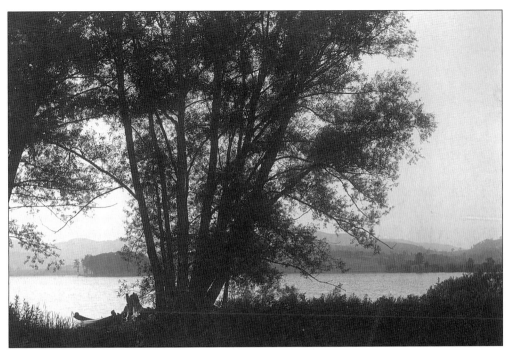

Pontoosuc Lake, c. 1920. This photograph was taken by Henry Seaver. Seaver was a Pittsfield architect who designed, among other buildings, the Berkshire Museum, the YMCA, and Ananda Hall, a Berkshire Cottage in Lenox. He was a talented amateur painter and photographer as well.

The Pontoosuc Outlet, c. 1940. Pontoosuc Woolen Mill once stood on the shores of the outlet, giving the lake its name. The Native American name for the lake was Shoonkeekmoonkeek. However, the white people called it Lanesboro Pond until it became known as Pontoosuc. (Photograph by Arthur Palme.)

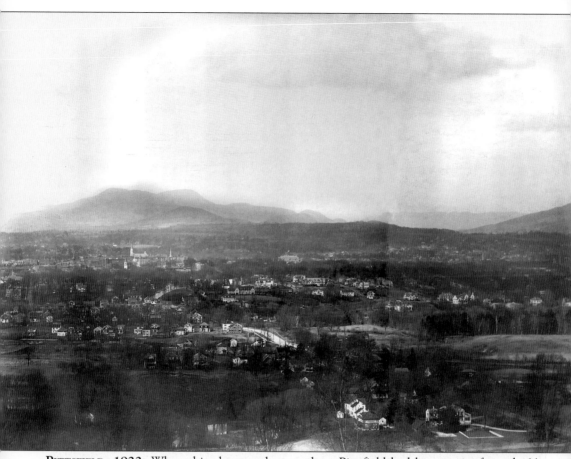

PITTSFIELD, 1922. When this photograph was taken, Pittsfield had been a city for only 11 years. Despite rapid population growth and the expansion of the Stanley Electrical Manufacturing plant on Silver Lake, Pittsfield retained its New England charm, nestled among the Berksire Hills and surrounded by lakes, forests, and rivers. (Photograph by H.E. Robbins.)

Three

THE FIRST CITY

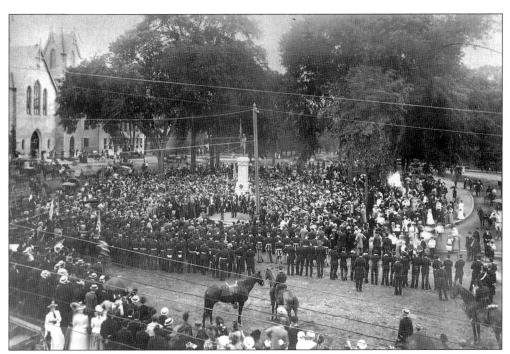

ANNIVERSARY CELEBRATION, 1911. The town celebrated the 150th anniversary of its incorporation with three days of festivities surrounding the Fourth of July. The anniversary was marked with church services, a musical pageant, many speeches, and, of course, fireworks. A parade of 2,000 General Electric workers featuring electric lights demonstrated the new importance of this industry to Pittsfield.

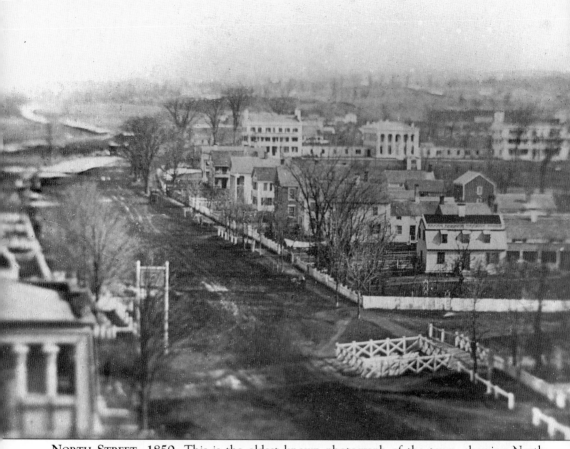

NORTH STREET, 1850. This is the oldest known photograph of the town, showing North Street near the Maplewood Young Ladies Institute. This was the site of a prisoner of war camp for British officers during the War of 1812. In 1826, Lemuel Pomeroy, who constructed buildings for a boys' school called the Berkshire Gymnasium, purchased the land. In 1836, it became a girls' school and, in 1841, the Pittsfield Young Ladies Institute was founded. The community had little faith in the school's purpose and viability, denying the principal enough credit to buy a barrel of flour when the school first opened. In just a few years, however, the school had gained a national reputation. Under new directorship in 1854, the school's name was changed to Maplewood and continued in operation until 1887, when it was converted to a fashionable summer hotel.

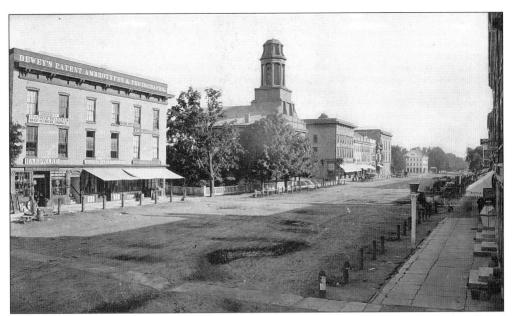

NORTH STREET, 1860. This view of North Street looks south toward Park Square, the edge of which can be seen just in front of the Backus Building. The First Baptist Church, in the center, was built in 1849 on a corner of the Old Burial Ground. It was sold in 1932 and was soon torn down to make way for the Onota Building.

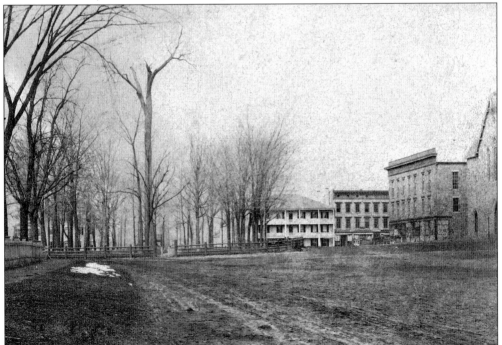

PARK SQUARE, C. 1860. Park Square looks quite desolate in this winter scene. The broad muddy roads were difficult to travel. The streets of Pittsfield were not paved until 1903, when areas around Park Square were paved. By 1915, only three and a half miles of roads had been completed.

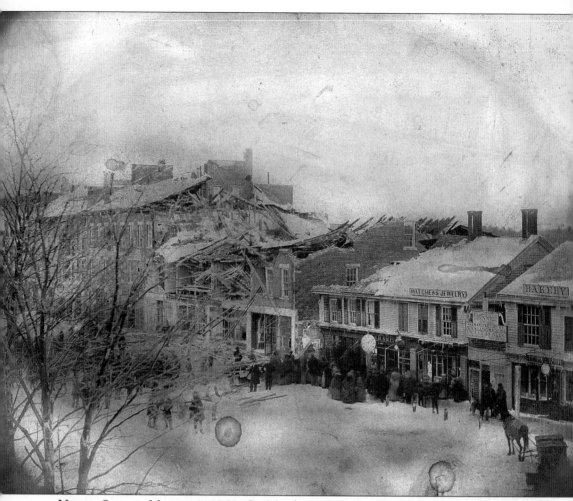

NORTH STREET, MARCH 4, 1862. On March 4, 1862, tragedy struck downtown Pittsfield. A building on North Street that housed 14 businesses and several apartments collapsed under the weight of snow and ice that had built up on the roof. Three people died and many more were injured, including five people who were rescued from the basement of an adjacent building. It is doubtful that any of the injured relied on Renne's Pain-killing Magic Oil sold in the shop next door. William Renne's oil was guaranteed to cure bites, stings, lame joints, cholera, sore eyes, neuralgia, kidney problems, and many other ailments. It could be used internally and externally.

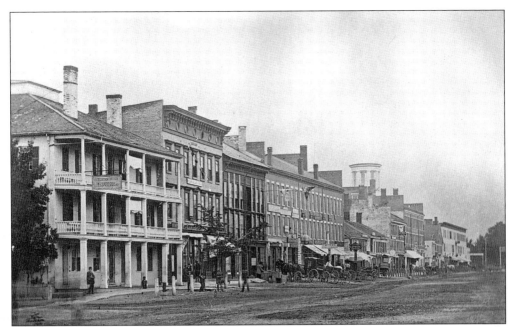

NORTH STREET, C. 1855. This scene shows the street from the corner of West and North Streets. The Berkshire Hotel, at left, was torn down in 1868 to make way for the Berkshire Life Insurance Building.

SOUTH STREET, 19TH CENTURY. Pittsfield's wide, shady streets provided respite from the busy town.

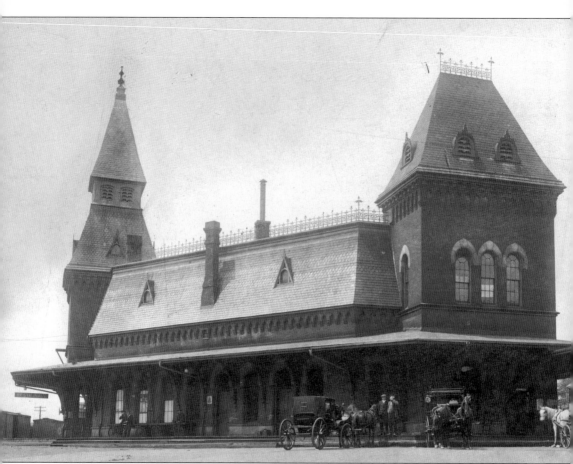

UNION STATION, 1870s. Located on West Street, the station was built in 1866. Triangular in shape, the magnificent building was torn down by the New York, New Haven, and Hartford Railroad Company in 1913, when a new and larger station was built. Pittsfield had become the central hub of railroad traffic in Berkshire County and was an important stop on the line between Boston and Albany. The railroads were central to Pittsfield's prosperity as the mills and other businesses required a means of transporting their goods to important markets such as New York City and Boston. The trains were also important in transforming the character of the town. As early as the 1840s, tourism in the area grew in importance, and the trains served as the principal means of bringing summer visitors to town. The area was a popular location for the grand summer homes built throughout the county in part because of the convenience of the train system.

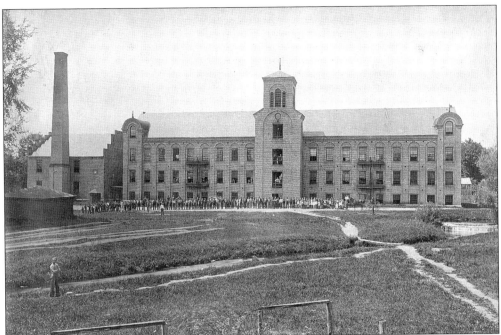

The S.N. & C. Russell Manufacturing Company, 1863. In 1845, Solomon and Charles Russell purchased a small carpenter's shop on Onota Brook and converted it to a cotton-batting factory. This mill was built in 1863 just opposite the batting mill. Here the Russell brothers employed about 125 people in the manufacture of woolen cloth. The mill closed in 1932.

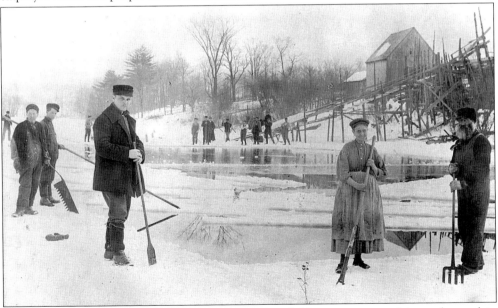

Ice Harvesting on Onota Lake, c. 1870. Pittsfield was a source of ice to be used in iceboxes and stored in icehouses for public consumption. The industry employed hundreds of people in the Berkshires, from farmers seeking additional income in the winter to commercial ice companies supplying ice to several states. The Boston & Albany Railroad bought 7,500 tons of Berkshire ice each year to use in their dining cars and water coolers.

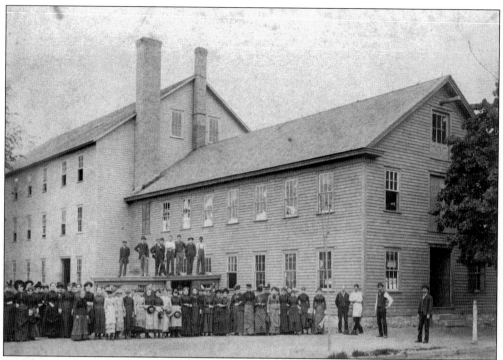

THE SPRAGUE AND BRIMMER SHIRT FACTORY, 1889. Founded in 1880, the company manufactured shirts and employed about 100 people. The vast majority of workers were women and girls.

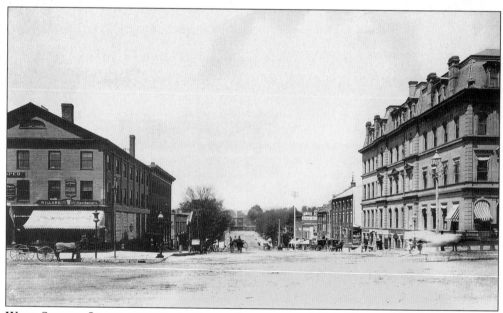

WEST STREET, LOOKING TOWARD UNION STATION, C. 1891. This wonderful shot of West Street shows Willard's Apothecary on the left and the Berkshire Life Insurance Building on the right. Just in front of the Berkshire Life building, note the blur that is just barely discernible as a white horse and buggy. (Photograph by S.S. Wheeler.)

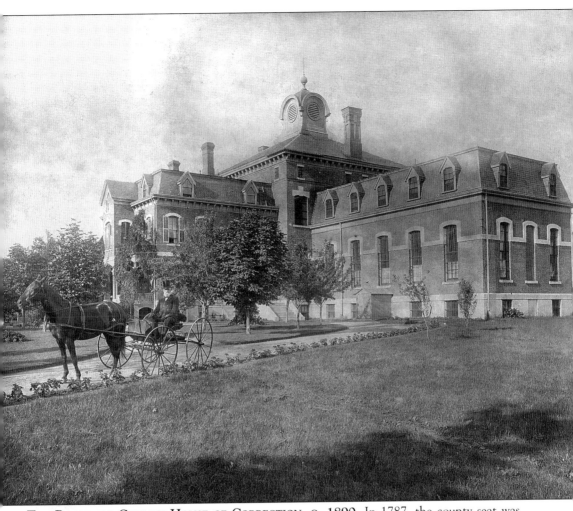

THE BERKSHIRE COUNTY HOUSE OF CORRECTION, C. 1890. In 1787, the county seat was moved from the first town in the Berkshires, Sheffield, to Lenox, citing the latter's more central location. That decision began 81 years of rancor between Pittsfield and Lenox. Arguing that since Pittsfield was the largest town and the commercial center of the Berkshires it should be the county seat, Pittsfield petitioned the state legislature in 1812. The legislature agreed so long as a referendum of the Berkshire voters supported the idea. Four referenda were held in 1816, 1826, 1842, and 1854. Finally, in 1868, Pittsfield succeeded. A condition placed by the legislature was that the town would provide both a courthouse and a jail. The house of correction was built on Second Street in 1870 at a cost of $190,000 and was in operation until 2000. Sheriff John Crosby (1887–1896) poses in front.

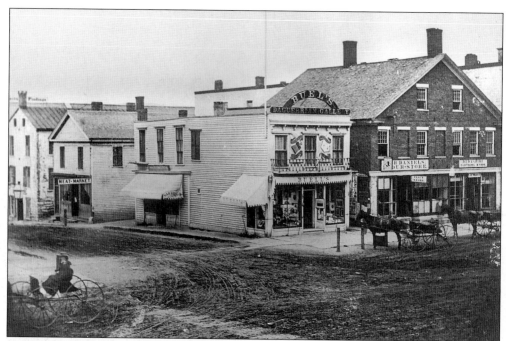

CORNER OF NORTH AND DEPOT STREETS, C. 1865. Buell's Daguerrian Gallery was a popular spot to have carte de visites taken. These small portraits designed for gift giving were produced by the 21 professional photographers working in Pittsfield in the 1860s and 1870s.

HORSE AND BUGGY AT PARK SQUARE, C. 1900. The horse and buggy was still a favorite mode of transportation well into the 1920s. Electric trolleys and automobiles were subject to mechanical breakdown and had difficulty making it up the steep Berkshire hills. In the winter, horses and sleighs did not require streets completely clear of snow to operate. It was not until 1922 that the city purchased snow plows.

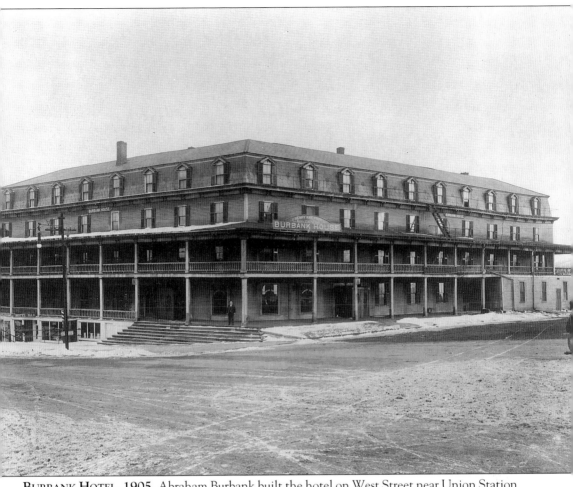

BURBANK HOTEL, 1905. Abraham Burbank built the hotel on West Street near Union Station in 1871 and ran it until 1877. It contained 150 guest rooms along with dining rooms, reading rooms, parlors, and a bar and café. The hotel was purchased in 1904 by Henry Hay, who closed it in 1910. It was torn down in 1911.

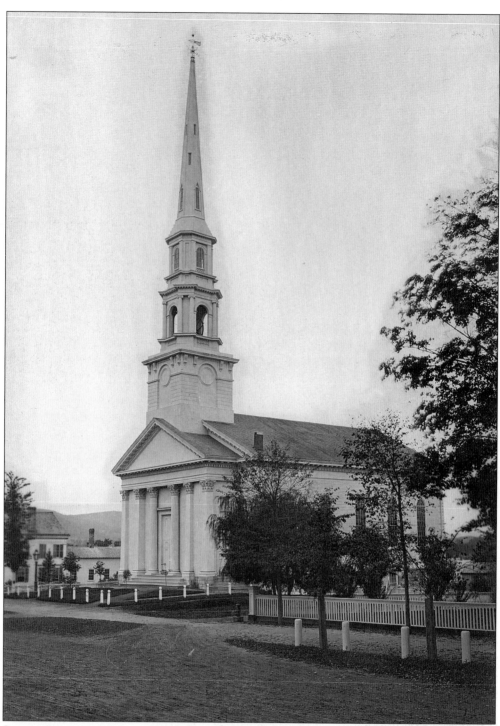

SOUTH CONGREGATIONAL CHURCH, C. 1860. Built in 1850, the church had been organized as a second location for the overcrowded First Congregational Church on Park Square. The original spire, shown in this picture, was damaged in a storm in 1859 and restored. In 1882, the unlucky restored spire blew down in a storm and was replaced by the current one.

FENN STREET ADVENTIST CHURCH, 1913. The first Jewish congregation in the Berkshires, Society Anshe Amunim, was formed in 1869. In 1927, a former Adventist Church on the corner of Fenn and Willis Streets was converted to the first temple in Pittsfield. (Photograph by Laura Cowles.)

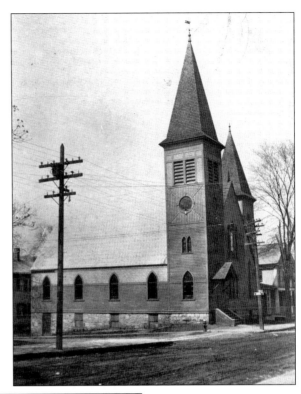

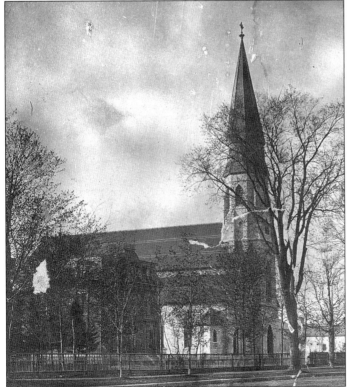

ST. JOSEPH'S CHURCH, c. 1890. The earliest known Catholic mass in Pittsfield was held in 1835 in a private home, with the first Catholic church built in 1844 on Melville Street. St. Joseph's Church was begun in 1864, but not completed until 1889. The Sisters of St. Joseph opened the school in 1897.

43

First Congregational Church, c. 1900 The present church was built in 1853, replacing the Bulfinch Church, which had been damaged by fire in 1851 and moved to the grounds of the Pittsfield Young Ladies Institute. The current church is built on the site of the original meetinghouse constructed in the 1760s.

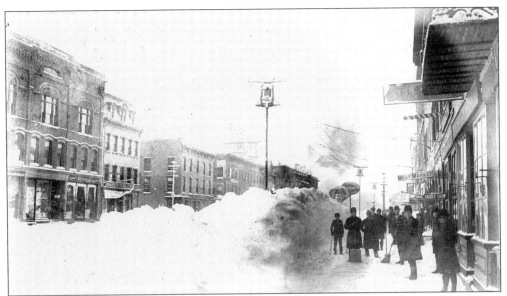

THE BLIZZARD OF 1888. On January 26, 1888, Pittsfield was hit by a strong storm that left more than 18 inches of snow on the ground. The wind caused the most problems, creating drifts up to 15 feet high, burying many trains. Teams of workmen were organized to clear streets and dig out the stalled trains, at least one of which was completely buried in snow so that only its smokestack was visible. (Photograph by W.E. Day.)

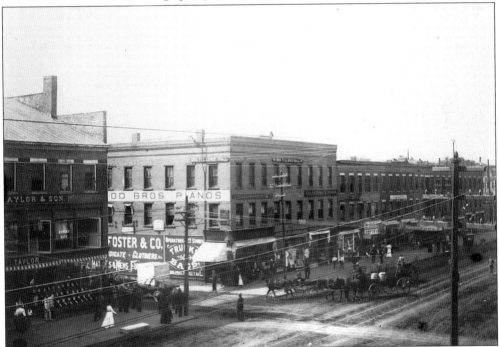

NORTH STREET, C. 1890. This photograph of a bustling downtown shows the trolley tracks and lines installed in 1889. The Berkshire Street Railway was the only trolley system in the country to operate in four states, running from Canaan, Connecticut, through the Berkshires to Bennington, Vermont, and over to Hoosick Falls, New York.

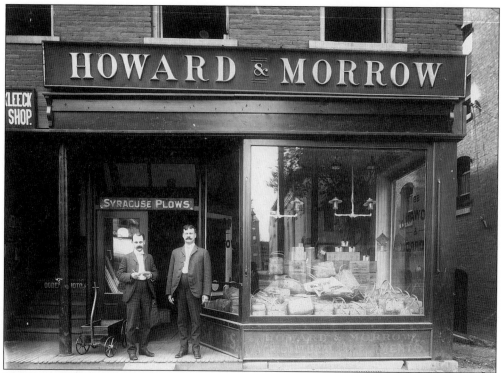

HOWARD & MORROW, 1893. At 59 North Street, Frank Howard (on left) and John C. Morrow opened their store in 1893. The store sold agricultural implements, seeds, fertilizers, lime, cement, and farming supplies. The store operated until 1960, in the later years under the name of Frank Howard alone.

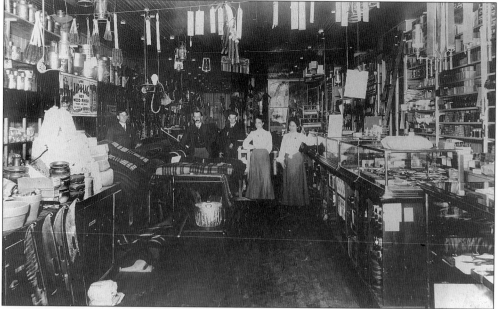

HOWARD & MORROW, C. 1905. Pictured from left to right are Fred McCarthy, Frank Howard, Frank Hudsell, Lillian Simmons, and Eva Delmarter.

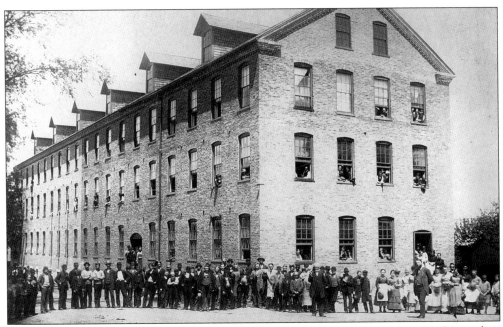

ROBBINS, KELLOGG & COMPANY, WHOLESALE SHOE MANUFACTURERS, C. 1880. Located on Fourth Street, the factory employed about 450 people making shoes for men and boys. Between 1870 and 1910, shoe manufacturing was the second largest industry (after textiles) fueling the Pittsfield economy. During those years, there were six shoe factories operating in Pittsfield.

ROBBINS, KELLOGG CO.,

WHOLESALE SHOE MFRS.,

FACTORY AND OFFICE,

64 FOURTH STREET,

PITTSFIELD, MASS.

OLIVER W. ROBBINS, President.

CHARLES W. KELLOGG, Secretary and Treasurer.

NEWTON A. MILLS, Superintendent.

SALESROOMS, 14 HIGH STREET, BOSTON, MASS.

ADVERTISEMENT FROM THE 1893 PITTSFIELD DIRECTORY. That year the directory listed 2 shoe factories, 26 independent shoemakers and cobblers, and 15 retail shoe stores.

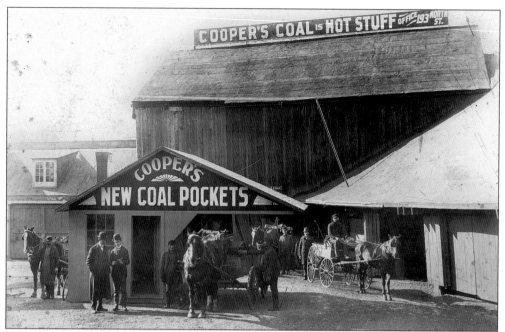

COOPER'S COAL, 1900. "Cooper's Coal is Hot Stuff." Located on North Street, Cooper's Coal was founded in 1898. It was one of several coal and wood companies operating in the town, providing for the heating and cooking needs of the community.

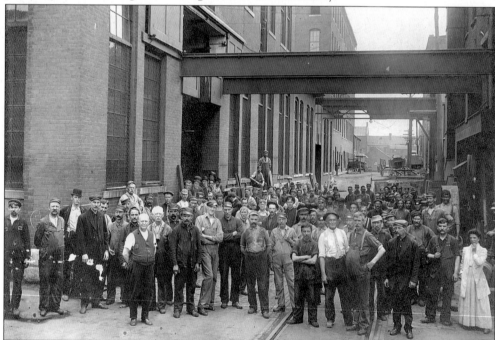

E.D. JONES, 1910. Founded in 1845, the company moved to Pittsfield in 1867. Specializing in the manufacture of machinery for the paper industry, the plant supported the many paper mills in Berkshire County. During World War II, the company switched to producing military hardware and materials for the Manhattan Project.

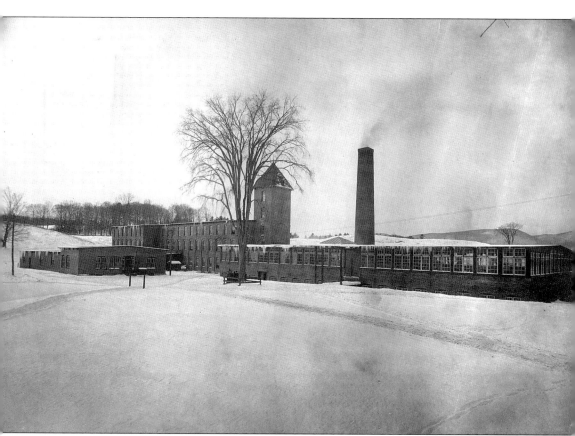

PECK'S MILL, 19TH CENTURY. In 1844, Elijah Peck built a cotton-warping mill on Onota Brook. In 1864, the firm's new owner, Peck's nephew Jabez L. Peck, added a flannel mill. His son Thomas D. Peck took over the firm upon his father's death in 1895, running it until 1910, when it was sold to the Berkshire Woolen and Worsted Company. Peck had an unusual brush with national history through his ex-wife, Mary Hulbert Peck, who had an affair with Pres. Woodrow Wilson and was expected to marry him after his first wife, Ellen, passed away. The former Mrs. Peck was quite surprised to learn of Wilson's engagement to Edith Bolling Galt.

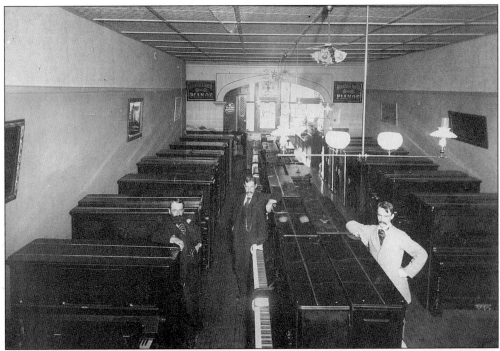

WOOD BROTHERS, C. 1900. Located on North Street, Wood Brothers was founded in 1883 and continued in operation until 1983, selling all manner of musical instruments.

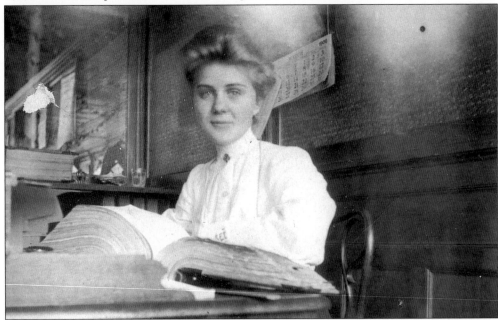

AN ENGLAND BROTHERS EMPLOYEE, 1906. England Brothers was founded in 1857 by Moses England, a Bavarian immigrant who operated his dry goods business on North Street until 1886. When he retired, his sons took over the operation, expanding it greatly. In its heyday, it was the largest department store in western Massachusetts. The store closed in 1988 and the building was finally torn down in 1998.

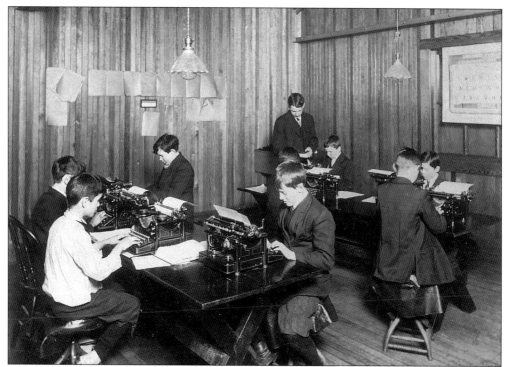

BERKSHIRE BUSINESS COLLEGE AND SCHOOL OF SHORTHAND, C. 1900. Located on North Street and operated by L.M. Holmes, the school taught bookkeeping, shorthand, penmanship, typewriting, and English. Its advertisement promised "competent help supplied offices."

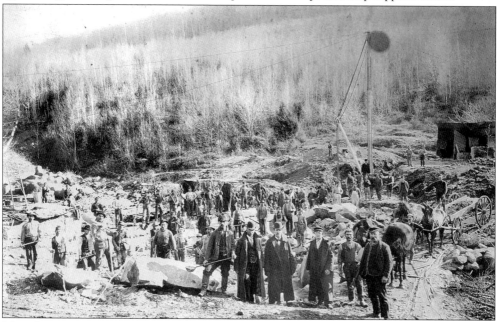

MILL BROOK DAM, 1910. As Pittsfield's population continued to grow at the turn of the century, so did its need for an adequate water supply. In addition to Ashley Lake and Sackett Brook, a new reservoir was added on Mill Brook in Lenox. (Photograph by S.S. Wheeler.)

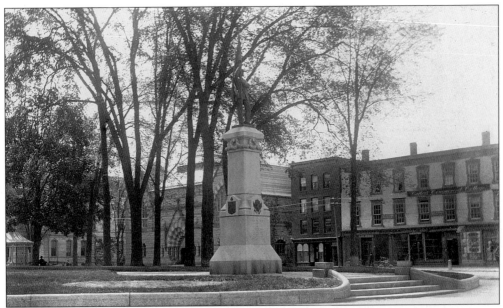

PARK SQUARE, C. 1880. This photograph shows Soldiers' Monument, designed by Launt Thompson, in Park Square. Across from Park Square stands the Berkshire Athenaeum, built in 1876. Thomas Allen, the grandson of the Fighting Parson, donated the funds for the building, which housed the lending library, the collections of the Berkshire Historical and Scientific Association, and an art gallery.

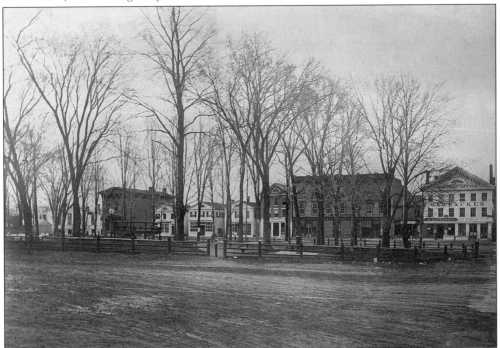

PARK SQUARE, C. 1865. This earlier photograph of Park Square shows the same view as above. Instead of the Berkshire Athenaeum, the early buildings of Bank Row are visible, including the three low white buildings that gave the block its nickname.

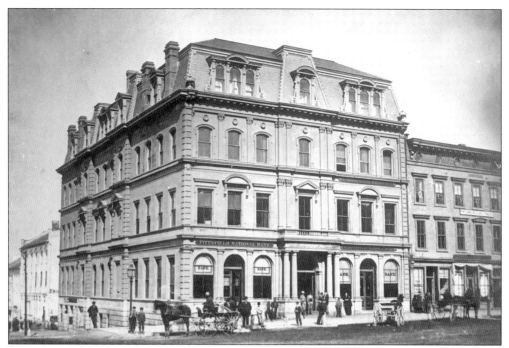

THE BERKSHIRE LIFE INSURANCE COMPANY, C. 1870. Berkshire Life was founded in 1851 by George Nixon Briggs, a former governor of Massachusetts. This magnificent building was built in 1868. At various times, the building also housed the post office and Pittsfield National Bank. Berkshire Life left in 1959 to take up residence at its new headquarters on South Street.

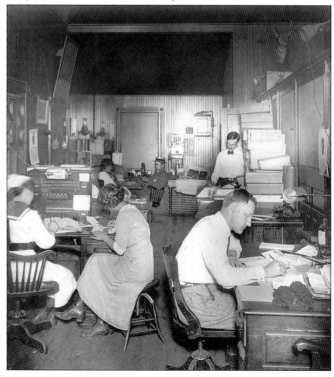

TACONIC MILL, C. 1915. This photograph shows a modern office establishment.

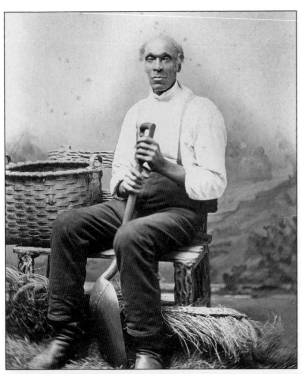

BENJAMIN WILSON, C. 1880. This interesting portrait of Benjamin Wilson—who worked for 30 years as a coal carrier for a Pittsfield freight company on Depot Street owned by Gerry Guilds—was printed on souvenir cards by Forester Clark, photographer.

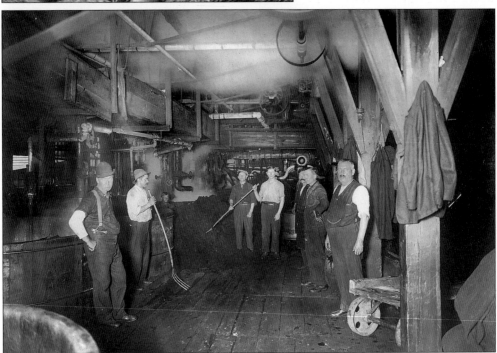

COAL ROOM, TACONIC MILL, C. 1900. The Taconic Mill was built in 1855 and made 4,000 yards of cassimere each week until 1873, when it lay dormant until 1880. The firm of Wilson and Glennon (later Wilson and Horton and still later James & E.H. Wilson) operated the mill until 1926.

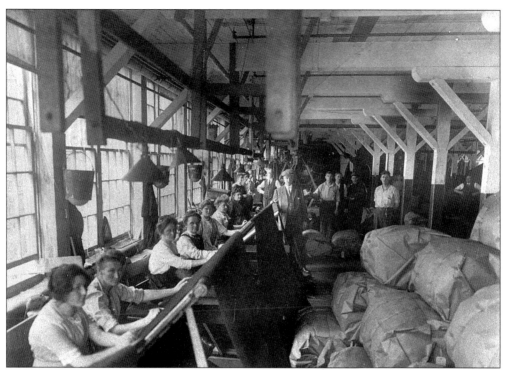

THE PONTOOSUC WOOLEN MILL, C. 1890. Built in 1827, the mill was in operation as the Pontoosuc Woolen Manufacturing Company until 1929, when it was leased by the Wyandotte Worsted Company, which operated it until 1964.

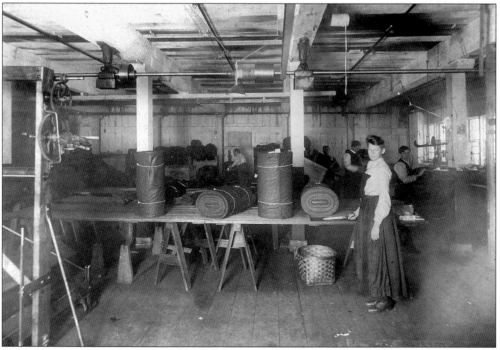

PECK'S MILL, C. 1910. (Photograph by A.D. Copeland.)

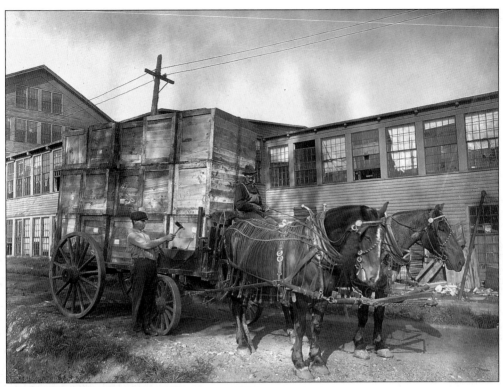

A Taconic Mills Delivery Wagon, c. 1900.

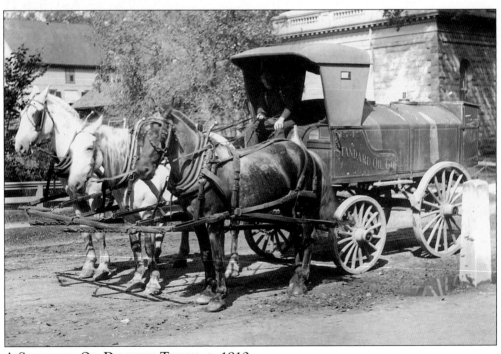

A Standard Oil Delivery Truck, c. 1910.

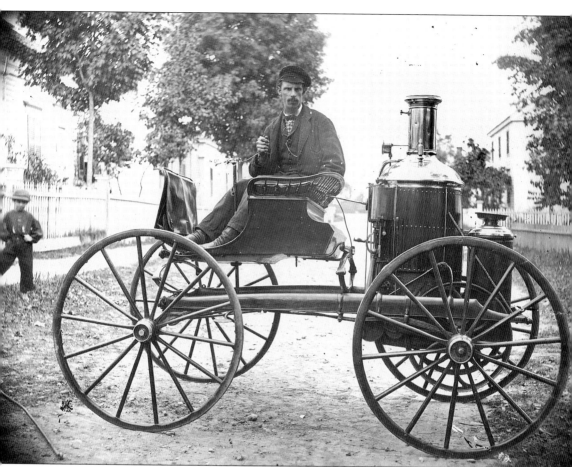

A Steam-Powered Automobile, c. 1880. For a time at the beginning of the 20th century, Pittsfield was the site of several automobile manufacturers. Steam cars were introduced in the United States as early as the 1880s. In 1904, the Berkshire Automobile Company began operation. In 1905, Alden Sampson began building trucks at a plant on the site of the old L. Pomeroy's Sons mill. The Stilson Motor Car Company was founded in 1907. All three companies were out of business by 1912.

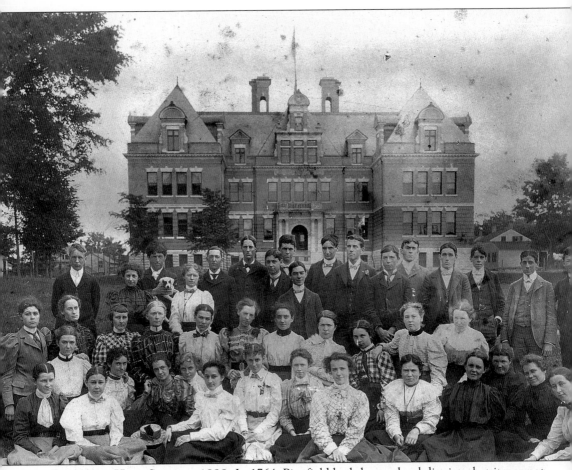

PITTSFIELD HIGH SCHOOL, 1898. In 1764, Pittsfield had three school districts, but it was not until 1792 that the town complied with state law and established a grammar school, located in the town hall. Financial support was withdrawn from the school, however, in 1824. In 1849, the town once again decided a grammar school was needed, and a school building was built on a corner of the Old Burial Ground. In 1869, the system of district schools was abolished in favor of townwide graded schools. In 1870, the grammar school became the high school and moved into the old Berkshire Medical Institution on South Street. The school burned in 1876 and was replaced. By 1897, however, it had grown too small and this building on the common was constructed. It was abandoned as a school in 1932 in favor of a new one on East Street.

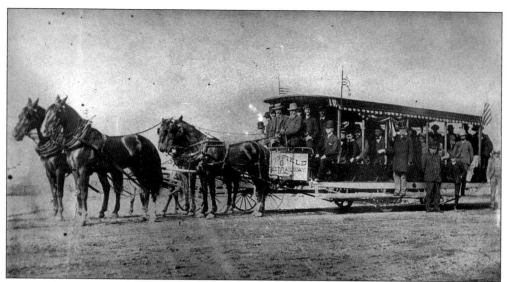

A STREETCAR, C. 1886. Horse-drawn streetcars were introduced to Pittsfield in 1886 and continued in operation until 1891, by which time they had been replaced by electric trolleys.

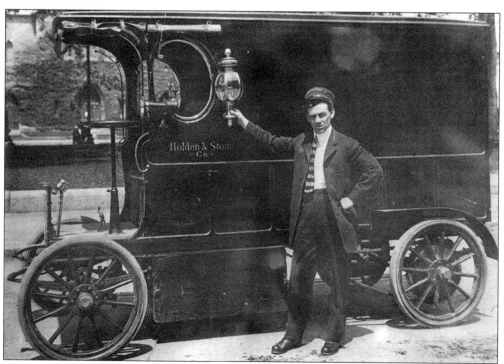

HOLDEN & STONE DELIVERY TRUCK, C. 1905. Founded in 1844 by Henry G. Davis, the business went through many name changes until Harry Holden and Frank Stone took over in 1902. Marshall Field worked there as a young man before he returned to Chicago in 1865 to start his own store. Holden & Stone closed in 1969.

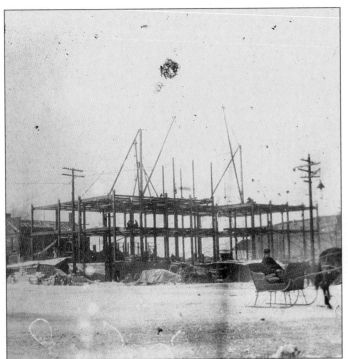

THE WENDELL HOTEL, 1898. This photograph shows the construction of the Wendell Hotel, located at the corner of West and South Streets. The owner, Samuel W. Bowerman, was only 23 when he built it. Within the year, he was out of business and the hotel was leased to another firm.

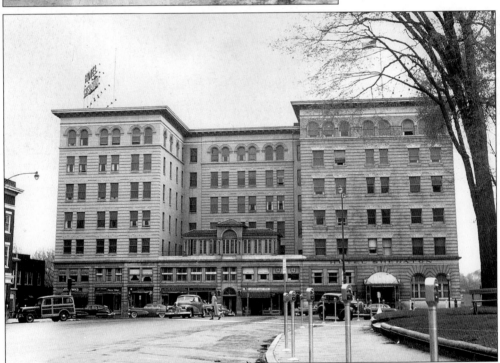

THE SHERATON HOTEL, C. 1950. In 1924, the owner of the Wendell Hotel, Napoleon Campbell, added a second wing to the structure, and he enlarged it further in 1930. The Wendell was purchased by the Sheraton Hotel chain in 1944 and was razed in 1965. The Berkshire Common was built on the site a few years later.

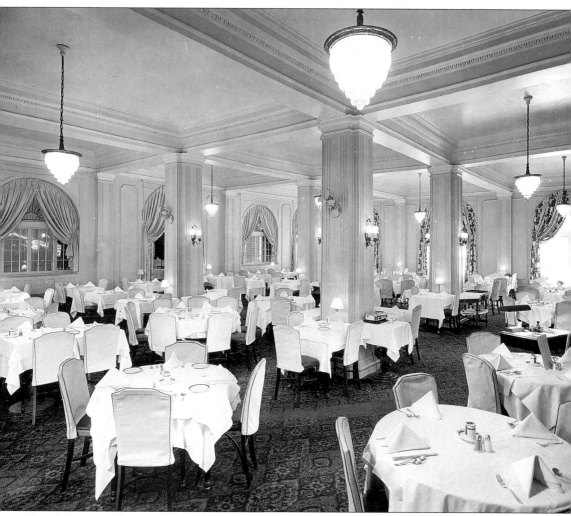

THE WENDELL HOTEL, 1955. The Wendell was an elegant addition to Pittsfield life, as this photograph of the dining room shows. (Photograph by H.S. Babbitt Jr.)

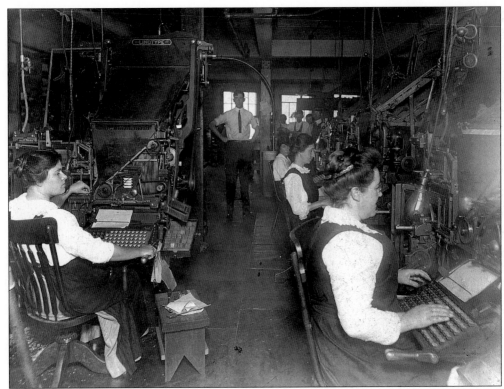

EAGLE PUBLISHING COMPANY COMPOSING ROOM, C. 1900. The company was formed in 1891, taking over the publication of the daily newspaper, the *Eagle*, until the firm's demise in 1995.

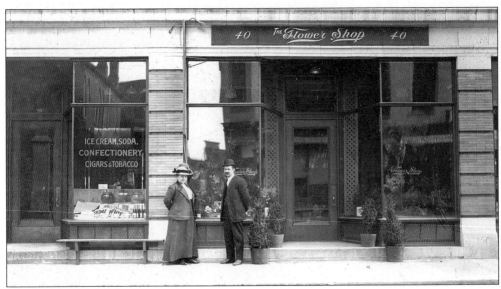

FENN STREET, C. 1910. Fenn Street was the perfect destination for Valentine's Day. Next to the Smith and Barnes Flower Shop was Ralph Pezzene's confectionary.

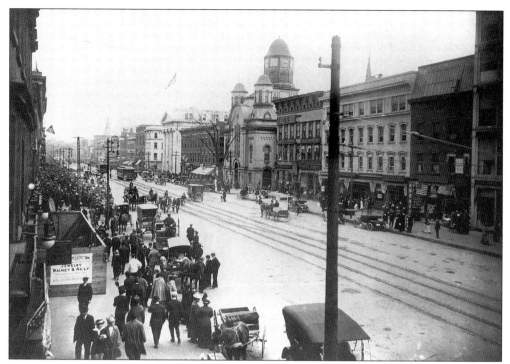

NORTH STREET, MAY 4, 1914. This marvelous picture shows cosmopolitan Pittsfield as the crowds gather for the Masonic parade.

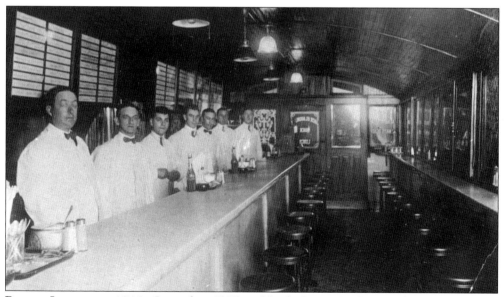

BRIDGE LUNCH, C. 1910. Opened in 1917 on North Street, Bridge Lunch was a good old-fashioned diner that remained in business until 1979. It was torn down in 1982.

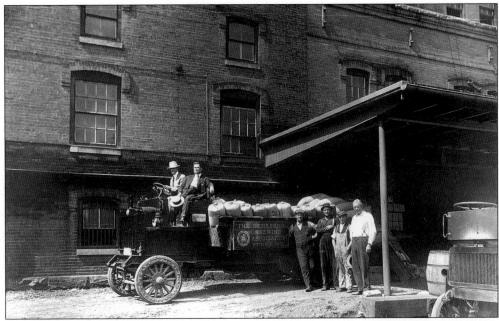

THE BERKSHIRE BREWING ASSOCIATION, C. 1905. Two German immigrants, Jacob Gimlich and John White, purchased a small brewery in Pittsfield in 1868. Under their guidance, the business grew to produce 325 barrels of beer each day. Incorporated in 1892 under the name Berkshire Brewing Association, the brewery shipped its product all over the United States. Prohibition put it out of business in 1919.

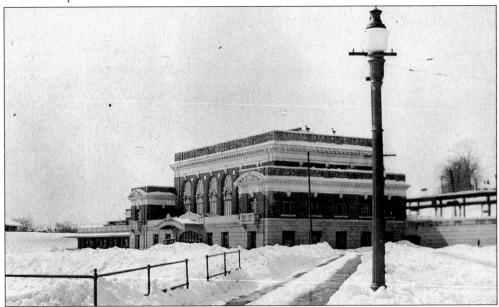

UNION STATION, 1914. The magnificent Union Station built in 1866 had become too small for Pittsfield's growing importance as a railroad and industrial center. The New York, New Haven & Hartford Railroad Company purchased the Burbank Hotel property and built the new Union Station on the site, then razing the old station. The 1914 station was razed in 1961 and replaced by a small Lexan cubicle.

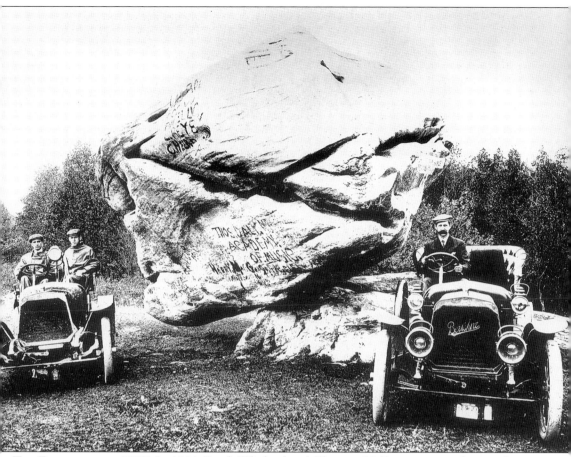

THE BERKSHIRE, C. 1907. In 1904, Frank Whyland and Clarence Hollister, two employees of the Stanley Electric Company, incorporated the Berkshire Automobile Company. By 1905, they had produced their first automobile in their factory on Renne Avenue. The company received 100 orders for automobiles that first year, the factory's full capacity. In 1907, offices were established in Providence, Boston, and New York. In 1908, a Berkshire sold for around $3,000 and could make it from Pittsfield to Boston in five and three-quarter hours. The Berkshires themselves were an important selling point in the advertising of the car, as this promotional photograph in front of Balance Rock illustrates. The company's slogan was "Made and Tested in the Berkshire Hills." During the years between its founding and its demise in 1912, the company produced six different models in several body styles and manufactured at least one truck. While the Berkshire performed adequately in racing competitions and at auto shows, it lagged behind the competition in quality, and the company continued to face financial difficulties, closing in 1912.

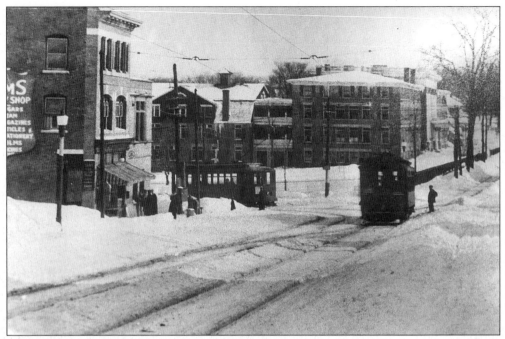

WAHCONAH AND NORTH STREETS, 1916. Travel in the drafty trolleys through the snowy streets could be only just preferable to walking because of the difficulties the trolleys had in maneuvering through the snow and the mechanical problems that also plagued them.

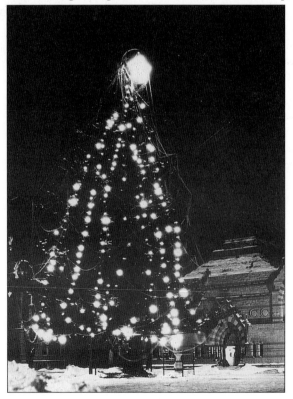

PARK SQUARE, 1914. Electric lights were a new and exciting modernization when the Christmas tree in Park Square was lit in 1914. This photograph was taken by Laura Cowles, who experimented frequently with nighttime photography.

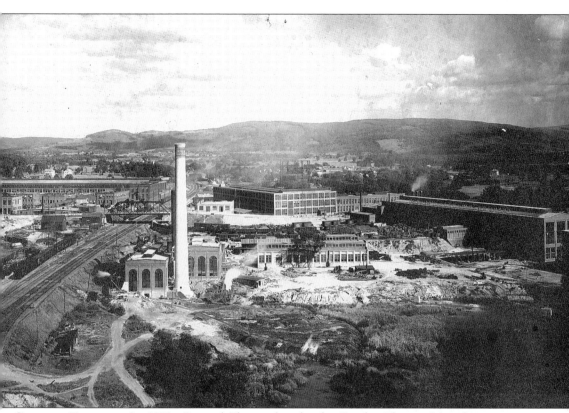

GENERAL ELECTRIC. In 1903, General Electric bought the Stanley Electric Manufacturing plant at Morningside and began a relationship with Pittsfield that was to shape the town for the entire 20th century. Replacing textiles as Pittsfield's largest industry, by the 1940s General Electric employed more than 13,000 people, a number that began to decline in the 1950s. The company took good care of its employees, providing evening educational programs in the three Rs as well as in specific topics related to the electrical industry. It provided a mortgage program designed to help its employees purchase homes and provided for health care and a pension plan. In 1909, General Electric began work on the development of plastics, and the plastics division became as important as the transformer division to the area economy. The transformer division closed in 1987.

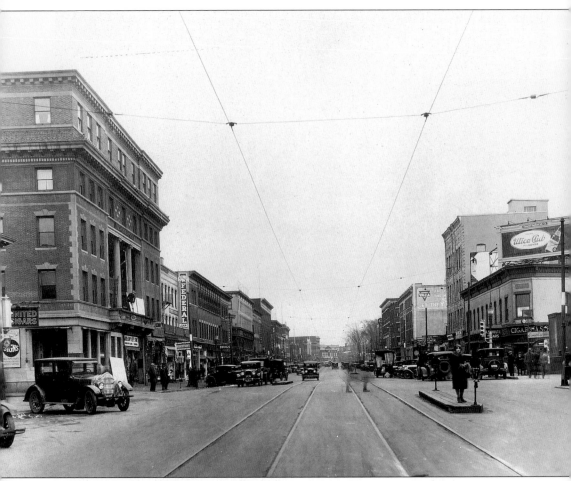

NORTH STREET, 1920s. The 1920s were uneventful for Pittsfield. The population increased 25 percent during the decade, the city installed its first traffic lights, and two women were elected to the school committee. Operating at half-capacity in 1920, General Electric was expanding rapidly by the end of the decade, emerging from the postwar depression that had plagued the city. Automobiles were becoming increasingly popular, thus increasing tourism's role in the local economy. Optimism about the city's future would end with the 1929 stock market crash. (Photograph by H. Cooper.)

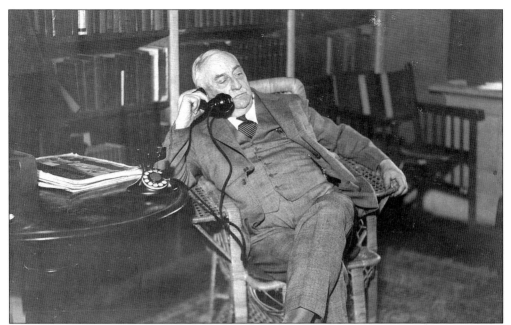

CECIL GAMWELL, 1931. The telephone had an inauspicious beginning in Pittsfield, but by the time the first dial telephone was introduced, it warranted a photo opportunity. In 1877, the first telephone demonstration was held at the Academy of Music. An organ and cornet were played in Westfield and the sound transmitted by telephone to Pittsfield. Only 300 people purchased tickets to the event, not enough to pay expenses, and only a few of them heard the music.

ALLEN STREET, C. 1940. The post office building (right) was built in 1911 and later became city hall. Straight ahead is the First Methodist Church.

TROLLEY, C. 1929. The Berkshire Street Railway Company was founded in 1901 and ran until 1930, when the trolleys were replaced by buses. In 1915, there were 25 miles of track within the city. A popular line was the one from Park Square to Pontoosuc Lake. The company actually created two amusement parks, one in Pittsfield and one in Great Barrington, simply to increase business. (Photograph by Laura Cowles.)

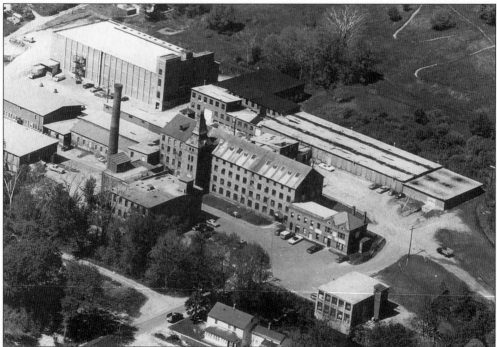

PONTOOSUC MILL, C. 1960. This picture demonstrates the long-lived importance of the textile mills in Pittsfield's history. In the center stands the original mill building, built in 1827, while around it stand the modern buildings of the Wyandotte Worsted Company.

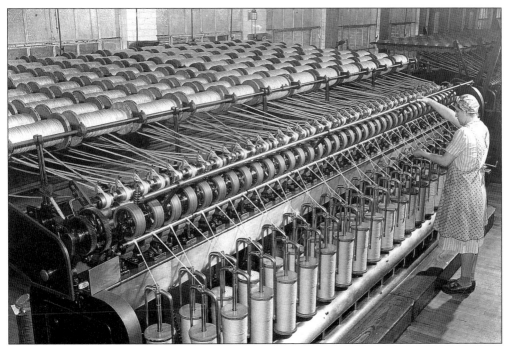

A.H. RICE AND COMPANY, 1940S. William B. and Arthur H. Rice began producing silk thread in a small factory in 1878. By the time the firm incorporated in 1905, the Rices had acquired an old woolen mill and built an additional building. As other mills in Pittsfield did, the Rice mill turned to the production of military goods during World War II, producing braid and thread for uniforms, nylon cord for parachutes, and thread for stitching powder kegs.

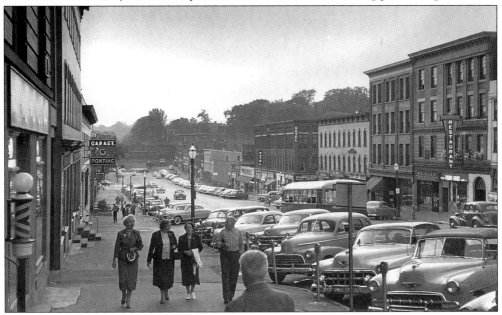

WEST STREET, C. 1950. In the 1920s, it was predicted that by 1950, Pittsfield's population would reach 90,000. The prediction did not come true, but Pittsfield was a thriving city. (Photograph by William Tague.)

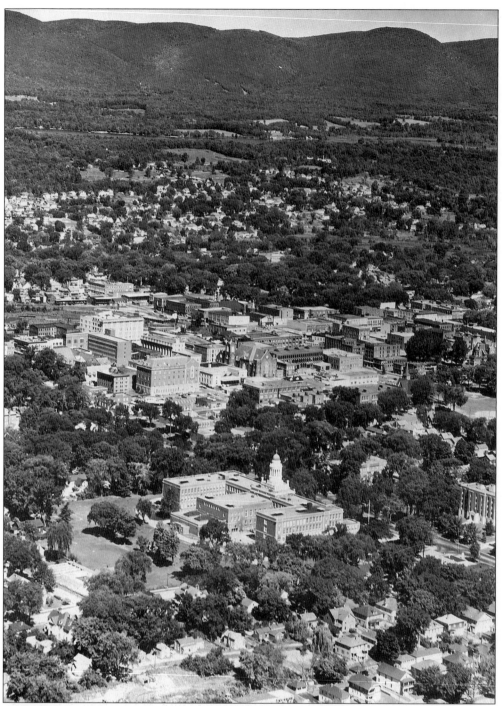

PITTSFIELD, C. 1965. Front and center is the controversial Pittsfield High School, built in 1932. The land chosen for the school was the site of some of Pittsfield's finest homes, including the one now known as the Longfellow House (called the Plunkett House at the time). Taken by eminent domain, the houses were located on a knoll (a favorite spot for sledding), which was flattened for the school. (Photograph by Colund Aerial Surveys.)

Four

A GREAT PLACE
FOR AUTHORS

ARROWHEAD, 1862. Herman Melville spent many summers in Pittsfield visiting his uncle's farm. In 1850, he decided to move to Pittsfield permanently, buying a home that he named for the artifacts he dug up while plowing. It was at Arrowhead that Melville wrote *Moby-Dick* along with three more novels, 16 short stories, and one volume of poetry. Many of his stories and poems were set in the Berkshires, including several set at Arrowhead. "A great place for authors, you see, is Pittsfield," wrote Melville in 1851.

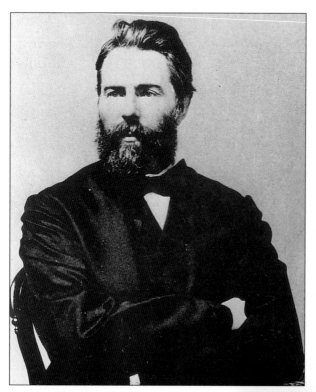

HERMAN MELVILLE, 1861. This daguerreotype, taken by Pittsfield photographer Rodney Dewey, is the earliest known photograph of Melville, who did not like to have his picture taken. Melville had been asked by the publisher of the *Literary World* for a daguerreotype to use in an article on American authors. At first Melville refused, but his mother finally convinced him several years later. Melville was 41 at the time. (Courtesy the Berkshire Athenaeum.)

VIEW OF MOUNT GREYLOCK, 1980. Melville purchased Arrowhead specifically for the view of Mount Greylock, which was similar to that he had known for years from his Uncle's house next door. He described the mountain as looking like the back of a sperm whale, and he dedicated his novel *Pierre* to the mountain. Greylock appears in many of Melville's short stories. (Photograph by Sidney M. Brown.)

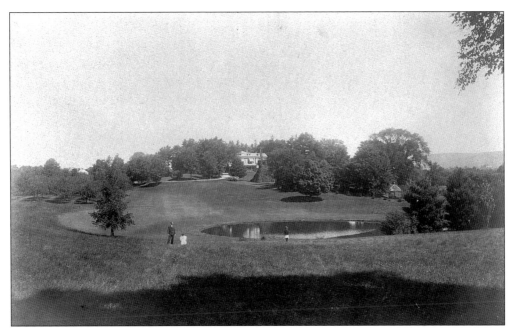

HOLMESDALE, C. 1910. Oliver Wendell Holmes was a renowned poet and the dean of the Harvard Medical School. He was also the great-grandson of Jacob Wendell, the original owner of the land that was to become Pittsfield. His summer residence, which he called Canoe Meadows (later called Holmesdale), was located on the road that now bears his name.

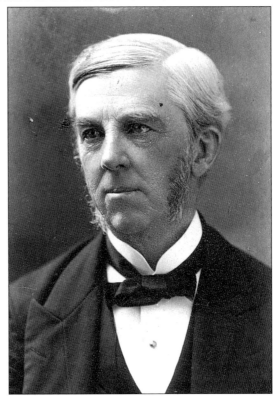

OLIVER WENDELL HOLMES, 1881. Holmes was a frequent speaker at city events and celebrations, often composing poems to honor the occasion. His son Oliver Wendell Holmes Jr. went on to become chief justice of the U.S. Supreme Court.

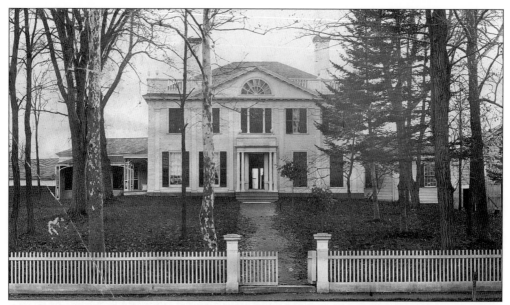

THE GOLD-APPLETON HOUSE, C. 1870. The house was built in 1790 and purchased in 1800 by Thomas Gold, whose granddaughter, Frances Appleton, married Henry Wadsworth Longfellow. Several weeks after their marriage, the Longfellows came to visit Pittsfield. Longfellow was taken with a clock in the Appleton house and later wrote his famous poem "The Old Clock on the Stairs" with that clock in mind. The house was destroyed to make way for Pittsfield High School in 1932.

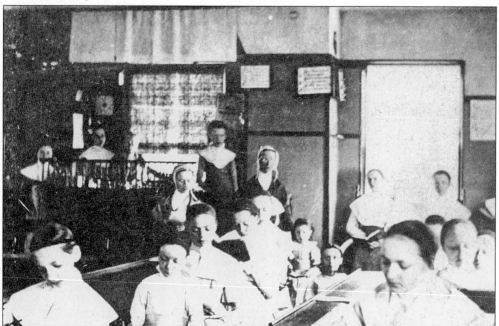

SHAKER SCHOOL, 1880S. This photograph is from a set of stereo cards called "Berkshire Views." It comes from the series "Pittsfield & Vicinity." Though the Shaker village is called Hancock, much of the Shaker land is located in Pittsfield, and the Shakers were an integral part of the Pittsfield community into the 1960s.

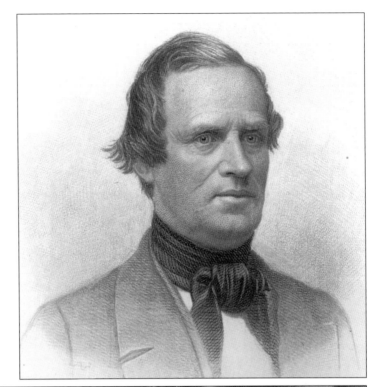

GOV. GEORGE N. BRIGGS, 1876. Born in South Adams in 1796, George Briggs moved to Pittsfield in 1842. The following year, Briggs was elected governor of Massachusetts, an office he held for seven one-year terms. He died in 1861 of an accidental gun shot wound.

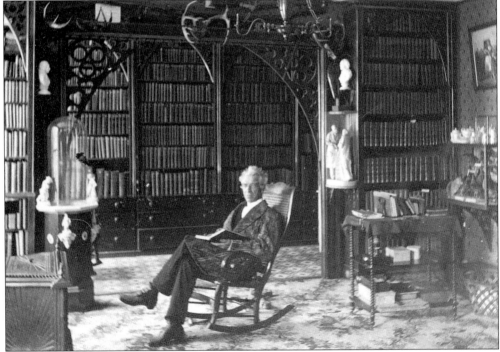

REV. JOHN TODD, 1873. Dr. Todd served as pastor of the First Congregational Church from 1841 to 1871. An influential citizen, he was also a widely published author and lecturer. Herman Melville based a character in one of his short stories on Todd.

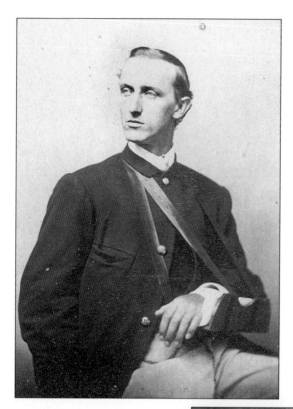

GEN. WILLIAM BARTLETT, 1863. Born in Haverhill in 1840, Bartlett enlisted as a private in 1861 and lost a leg at Yorktown. Put in command of the 49th Massachusetts Infantry, he led his men into battle on horseback because of his disability. In 1863, Bartlett was wounded again. Known throughout the North and South for his courage, he is the subject of a Herman Melville poem called "The College Colonel." (Photograph by Rodney Dewey.)

REV. SAMUEL HARRISON, 1897. Born in Philadelphia in 1818, Harrison came to Pittsfield in 1850 to become pastor of the Second Congregational Church, a post he held until his death in 1900. An active recruiter for the 54th Massachusetts Colored Regiment, he later became their chaplain, resigning in order to take up the fight for equal pay for black soldiers.

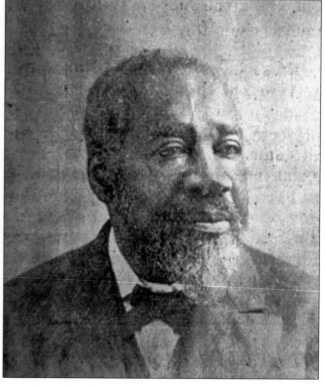

WILLIAM STANLEY, C. 1915. Stanley created the first alternating current electrical transformer, a feat he achieved in Great Barrington. In 1887, Stanley went to work for the Pittsfield Illuminating Company. In 1890, the Stanley Electric Manufacturing Company was created, manufacturing transformers. In 1903, General Electric bought the company and its plant at Morningside. Stanley remained a consultant with General Electric for many years.

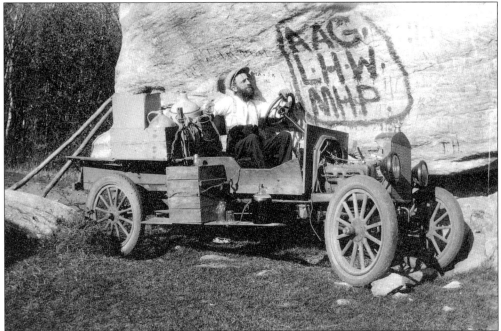

O.B. JOYFUL, C. 1920. Albert Franklin Tyler was an eccentric resident of Pittsfield. O.B. Joyful, as he was called, supported his family by selling food from the back of his Model T and doling out advice at a cost of $1 per question. In 1922, some 2,500 people came to hear him speak at the Majestic Theater on the question "Are women handsomer than men?" He died in 1961 at the age of 89.

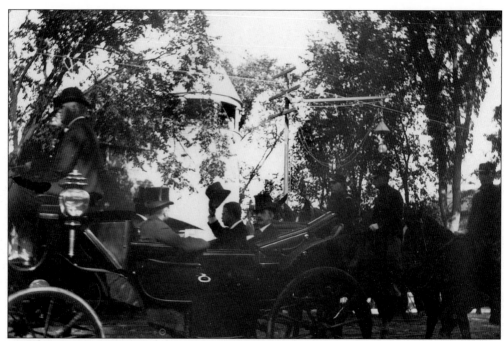

PRES. THEODORE ROOSEVELT, 1902. In September 1902, Pres. Theodore Roosevelt made a visit to Berkshire County as the guest of Dalton resident W. Murray Crane, the governor of Massachusetts. As part of his visit, Roosevelt appeared in Park Square before an enthusiastic crowd, after which he embarked by carriage for Lenox.

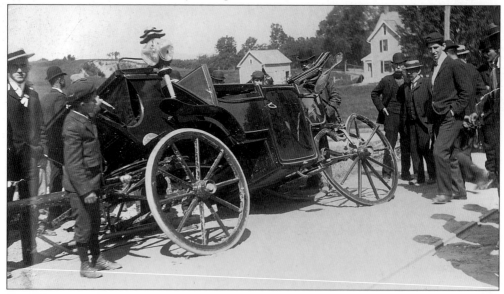

THE WRECK OF THE PRESIDENT'S CARRIAGE, 1902. At the bottom of the South Street hill, the president's carriage was hit by a Pittsfield trolley. While Governor Crane and President Roosevelt escaped serious injury, the driver of the carriage was severely injured and the president's bodyguard, William Craig, was killed along with one of the horses. The motorman and conductor of the trolley both pleaded guilty to a charge of manslaughter. (Photograph by S.S. Wheeler.)

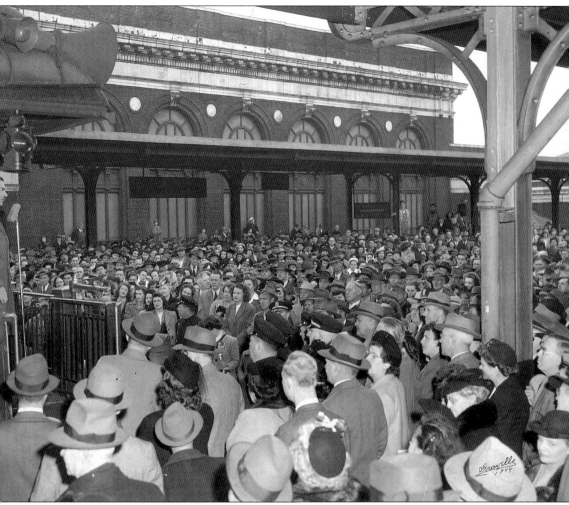

THOMAS DEWEY, 1944. Thomas Dewey ran for U.S. president twice and lost twice. Here he is shown speaking to a large crowd at Union Station during a campaign whistle stop. (Photograph by Gravelle Pictorial News.)

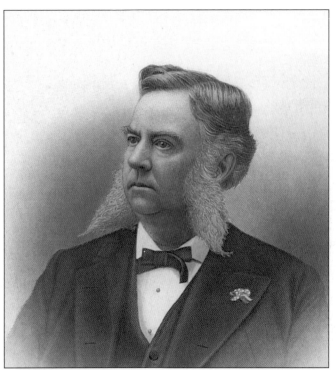

THADDEUS CLAPP.
Thaddeus Clapp was a descendant of the famous Clapp family, renowned Pittsfield carriage makers. Clapp became the superintendent of Pontoosuc Woolen Mill in 1865.

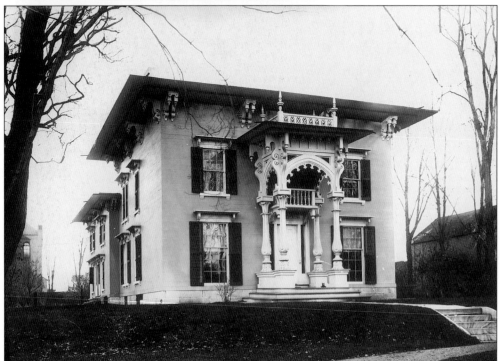

THE THADDEUS CLAPP HOUSE, C. 1880. This house, located at 6 Wendell Avenue, was a fine example of the many elaborate dwellings that were built in Pittsfield. The success of the mills had made many industrialists very wealthy.

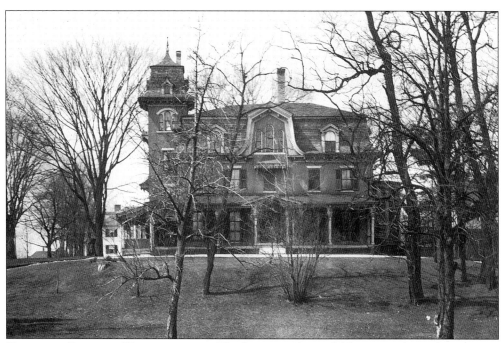

THEODORE POMEROY HOUSE, C. 1870. The Pomeroys' beautiful home was located at 48 West Housatonic Street.

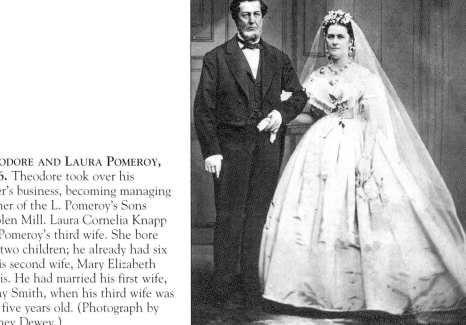

THEODORE AND LAURA POMEROY, 1866. Theodore took over his father's business, becoming managing partner of the L. Pomeroy's Sons Woolen Mill. Laura Cornelia Knapp was Pomeroy's third wife. She bore him two children; he already had six by his second wife, Mary Elizabeth Harris. He had married his first wife, Fanny Smith, when his third wife was only five years old. (Photograph by Rodney Dewey.)

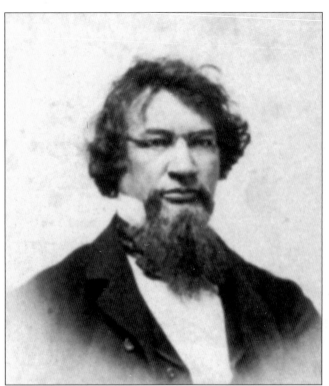

ENSIGN KELLOGG, C. 1860.
Kellogg was very active in
civic affairs in Pittsfield,
serving on numerous
corporate and charitable
boards. He had represented
Pittsfield in the state
legislature and served as
speaker of the house in 1850.
He was elected a state senator
in 1854. He was named
president of Pontoosuc
Woolen Mill in 1861.

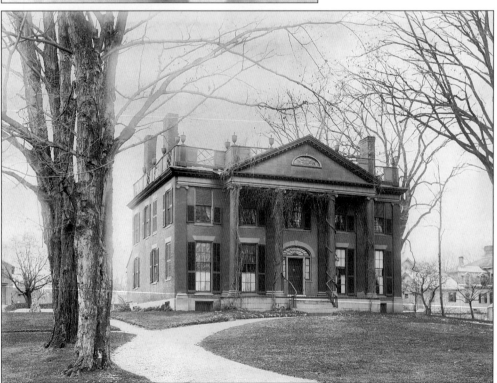

THE ENSIGN KELLOGG HOUSE, C. 1860. This house was located at 18 East Street.

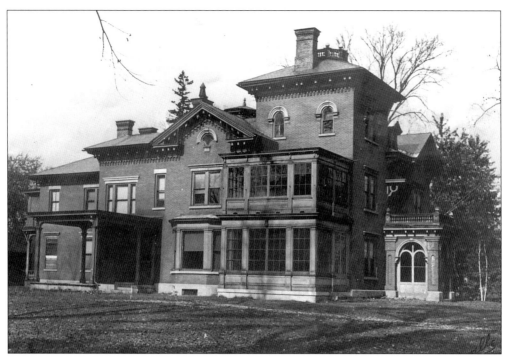

THOMAS COLT HOUSE, 1936. In 1851, Thomas Colt purchased a half-interest in the Wilson, Osborn & Gibbs paper factory, taking full ownership in 1855. In 1862, Colt demolished the old mill and built a new one, the area around which became known as Coltsville. The mill became Crane's Government Mill, making all the paper used in U.S. currency.

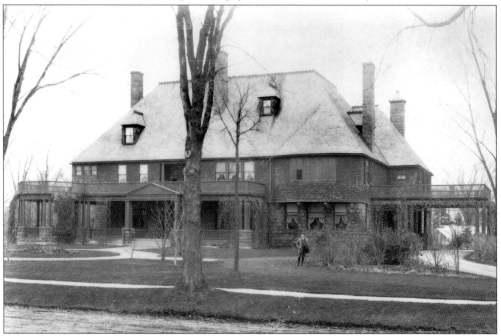

WHITTLESEY HOUSE, C. 1890. William Whittlesey moved to Pittsfield in 1886 and soon became a leader in the electrical industry and an advocate of the work of William Stanley.

PONTOOSUC WOOLEN MILL HOUSING, 1980. In contrast to the industrialists' homes, many of the mill workers lived in housing provided by their employers. Stearnsville, Coltsville, and Barkerville were all villages within the town created by the mills to provide housing, shopping, and schooling for the workers and their families.

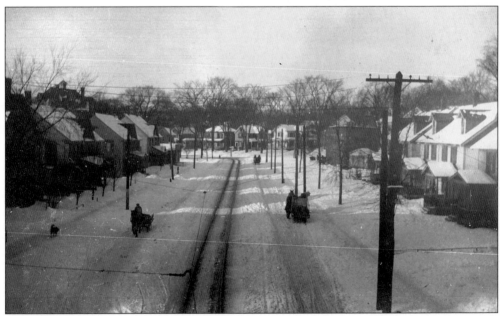

NEW WEST STREET, C. 1910. More prosperous factory workers, and those in the town with white-collar jobs, lived in the neat new neighborhoods springing up in Pittsfield.

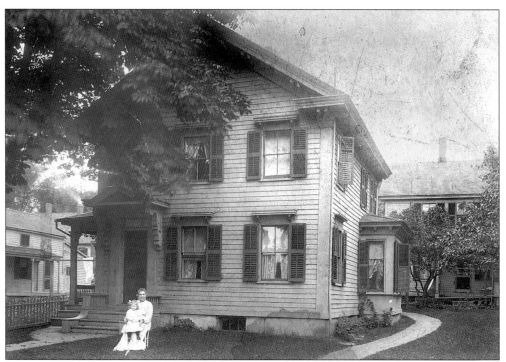

VAN VALKENBURGH HOUSE, 1903. The house was located at the corner of Melville and First Streets. Pictured are Helen Van Valkenburgh and her granddaughter Helen Greene.

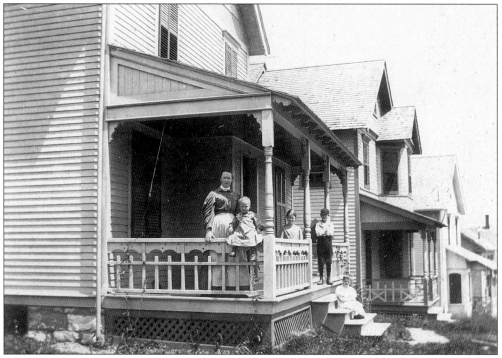

HOUSE ON LINDEN STREET, AUGUST 2, 1897. Here is another example of housing more typical to Pittsfield at the turn of the century.

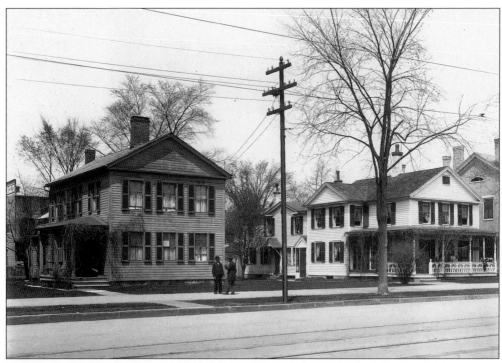

HOUSES ON NORTH STREET, C. 1900. Many of the fine homes built at the turn of the century are still standing today. (Photograph by Edwin Hale Lincoln.)

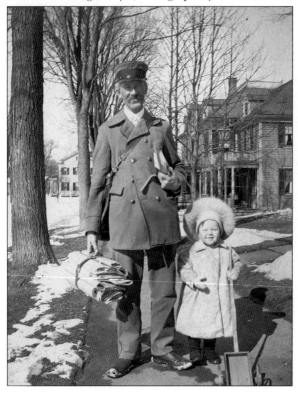

POSTMAN AND GIRL, C. 1915. Friendly faces and sharp-looking hats could be found throughout the city. (Photograph by Laura Cowles.)

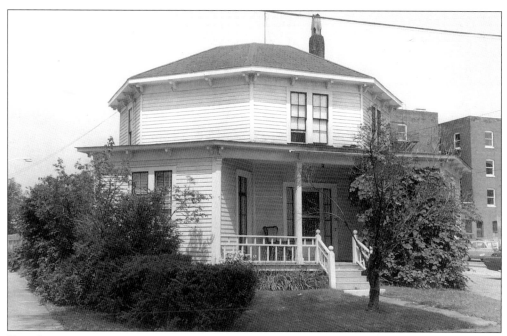

THE OCTAGON HOUSE, 1980. Built *c.* 1860 for the Woolison family, it was one of only about 300 octagonal houses built in America. The fad for houses of this shape revolved around the claim that they were more healthful to live in than conventional houses. (Photograph by E.R. Knurow.)

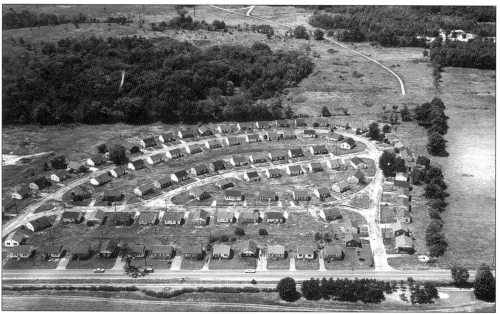

BENEDICT ROAD, 1965. In the 1950s, Pittsfield experienced a building boom. Little building had gone on during the Great Depression and the war, and postwar prosperity created a demand for housing without a population increase. Between 1945 and 1955, more than 2,600 single-family homes were built in the city. Much of the growth occurred to the northeast of the city as Pittsfield was unable to escape suburban sprawl. (Photograph by Eugene Mitchell.)

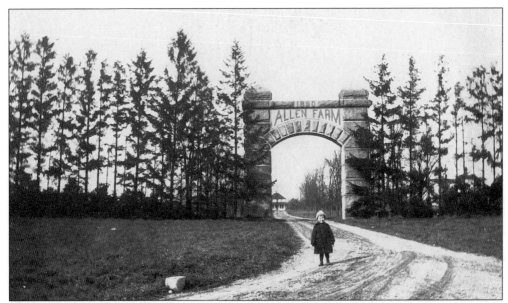

ALLEN FARM, C. 1915. William Russell Allen of St. Louis, the great-grandson of Fighting Parson Allen, was a millionaire with a passion for trotting horses. At his Pittsfield farm, which comprised 1,250 acres, he built a training barn, stables, and a half-mile time trail track. His breeding program was very successful, his most famous horse being Kremlin, who in 1892 set a new world record of 2.07 for a mile.

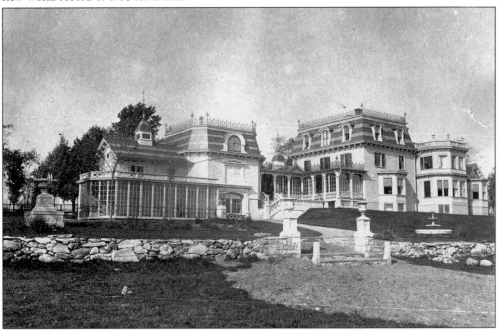

ABBY LODGE, C. 1880. Pittsfield was the site of numerous Berkshire cottages, the summer residences of the rich and famous. Abby Lodge was the summer residence of millionaire Richard Lathers, a relative by marriage of Herman Melville. The mansion, named for Lathers's wife, stood directly opposite Melville's home, Arrowhead, on Holmes Road. Unfortunately, the house burned to the ground in the 1890s.

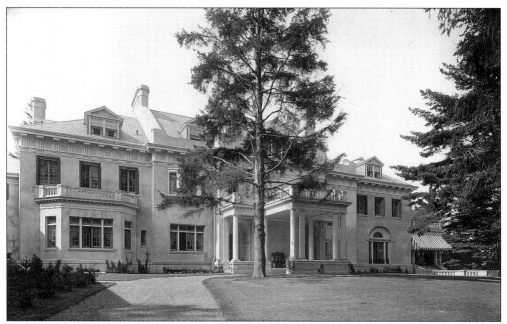

TOR COURT, C. 1910. Tor Court was built in 1908 for Warren and Evaline Salisbury, of the Kimball piano family, on the site of another summer home, Taconic Farm Estate, owned by Henry C. Valentine. In 1951, the house became the Hillcrest Hospital. (Photograph by Edwin Hale Lincoln.)

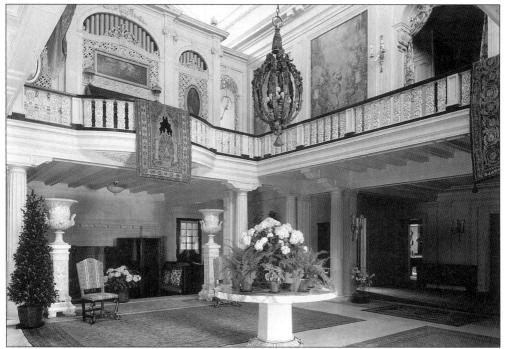

TOR COURT, C. 1910. This interior shot shows one of the magnificent rooms that were contained in this spectacular house located on the shores of Onota Lake. (Photograph by Edwin Hale Lincoln.)

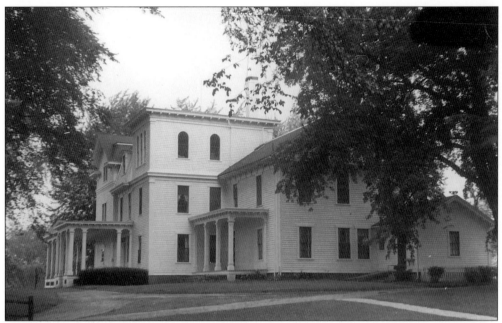

SPRINGSIDE, 1980. Springside was built *c.* 1870 as the summer residence of Frank and William Davol, brass manufacturers from New York City. The house and 74 acres were given by the last owner, Kelton Miller, to the City of Pittsfield for use as a park.

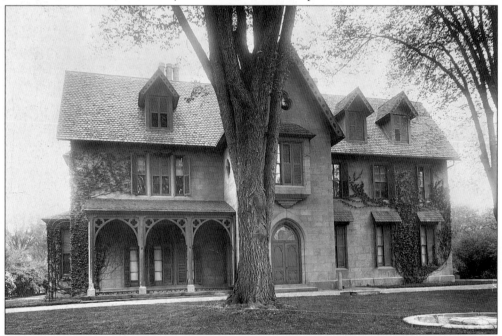

THE THOMAS ALLEN HOUSE, 1880. Thomas Allen was the grandson of Rev. Thomas Allen. The younger Allen was responsible for many civic improvements in Pittsfield, including the construction of the Berkshire Athenaeum. Allen, who lived in St. Louis, built his summer home on the site of his grandfather's parsonage in the 1760s. The magnificent home was razed in 1913.

Five

PITTSFIELD PROUD

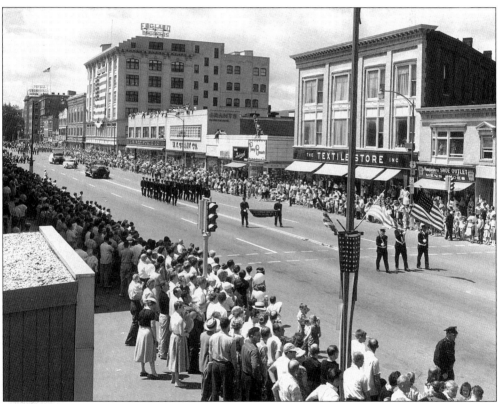

FIREMEN'S MUSTER PARADE, JULY 1957. It was not until 1844 that Pittsfield's old box-engine car, built in 1812, was replaced by two modern hand-operated fire engines. That year, the town's first engine company, the Housatonic, was formed. In 1885, horse-drawn engines were introduced. By 1916, the fire department was motorized. The whistle at Central Fire Station was used to signal fires, to call out the militia (10 blasts), and to announce days when school was canceled. (Photograph by William Tague.)

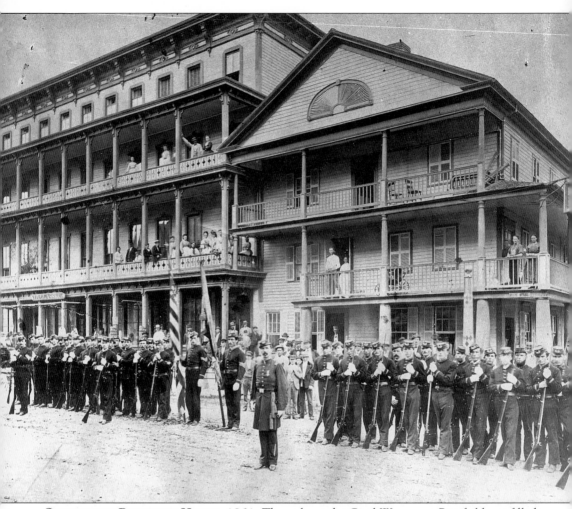

OUTSIDE THE BERKSHIRE HOUSE, 1861. Throughout the Civil War years, Pittsfield was filled with activity. As the site of Camp Briggs, an important recruiting and training camp for western Massachusetts, and as host to an army hospital, the streets were filled with soldiers. The presence of the railroad station as a central rendezvous spot for soldiers traveling from throughout the area added to the hustle and bustle of the war years. Pittsfield contributed soldiers to the 10th, 21st, 49th, and 54th Massachusetts regiments, among others, and the ladies of the town worked feverishly to assist the troops serving as nurses, laundresses, cooks, and seamstresses. Patriotic demonstrations were countered with the daily reading of the casualty list outside the courthouse.

SARAH MOREWOOD AND HER CHILDREN, c. 1860. Sarah and John Morewood moved to Pittsfield in 1850, purchasing the Melville House on South Street, now the Pittsfield Country Club. During the Civil War, Sarah was very active in the ladies' relief society and was known for her presentations of silk flags to each regiment that left the Pittsfield station for the battlefront. Sarah's son William married the Melvilles' niece Maria, and they lived at Arrowhead.

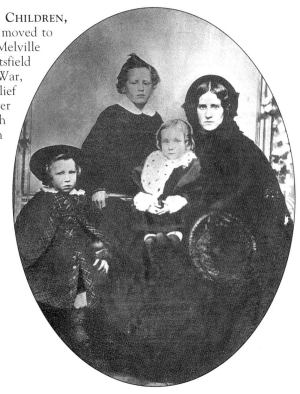

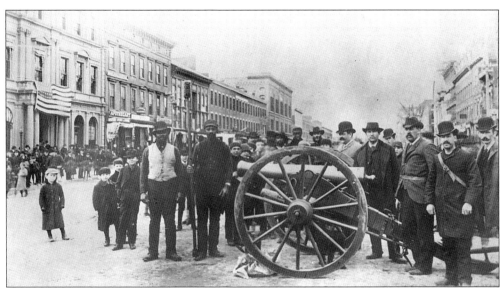

THE LEARNED BATTERY, 1888. Named for George Y. Learned, who provided the financial support for the cannon, the Learned Battery was fired at almost all patriotic occasions held in Pittsfield.

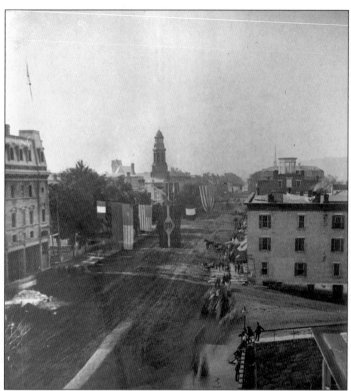

NORTH STREET, DEDICATION OF SOLDIERS' MONUMENT, 1872. Homes and businesses in Pittsfield have never been shy about showing their patriotism. In years past, it was common for buildings throughout the town to be decorated for Memorial Day and the Fourth of July as well as for special occasions such at the dedication of the Civil War monument in Park Square.

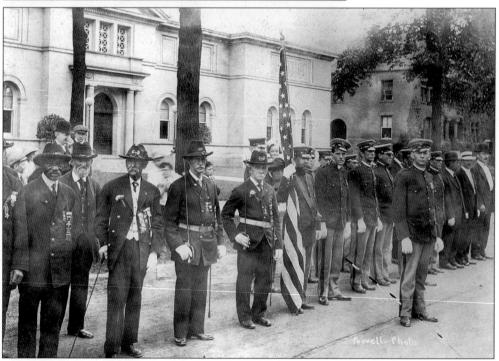

CIVIL WAR AND SPANISH-AMERICAN WAR VETERANS, C. 1910. This gathering was held outside the Museum of Natural History and Art.

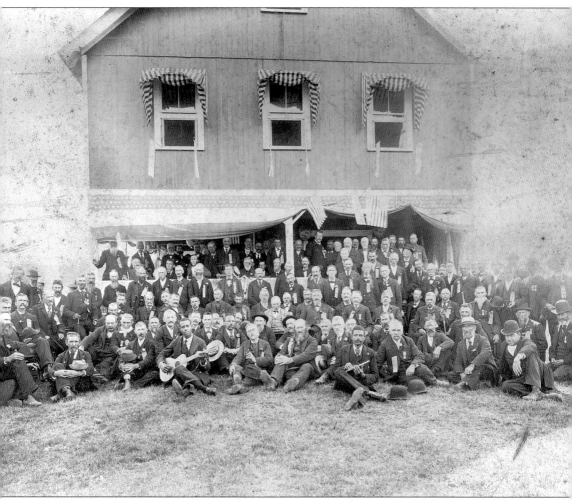

THE 49TH MASSACHUSETTS VOLUNTEER MILITIA, 1895. This reunion photograph shows members of the only regiment raised entirely in Berkshire County. The 49th was formed in 1862 and designated to serve for nine months. It was the first command that Col. William F. Bartlett received after having his leg amputated. The regiment trained at Worcester and on Long Island before being sent to Louisiana. There they took part in the battle of Plains Store and the assault on Port Hudson. Four members of the 49th received the Congressional Medal of Honor for their bravery in that battle.

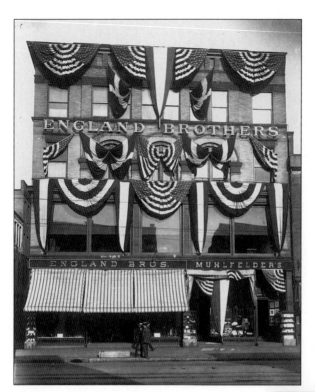

ENGLAND BROTHERS, C. 1918. No business showed more American pride than England Brothers, founded in 1857 by a German immigrant, Moses England.

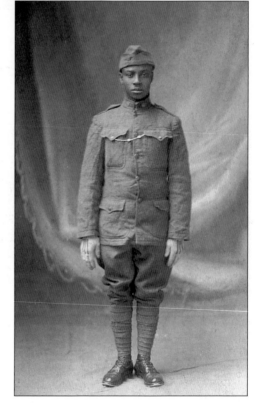

CHARLES PERSIP, 1918. The Persip family sent two brothers, Charles and Alfred to the war. The American Legion Post 68 in Pittsfield is named after Charles, who was a founding member.

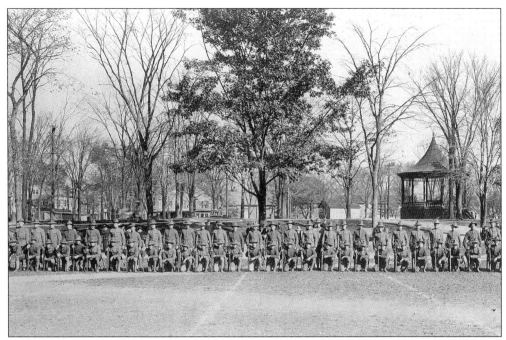

WORLD WAR I TROOPS. When America entered the war, Pittsfielders answered the call. Here, troops pose for a formal portrait before embarking for camp in Greenfield and then overseas. (Photograph by W.H. Benedict.)

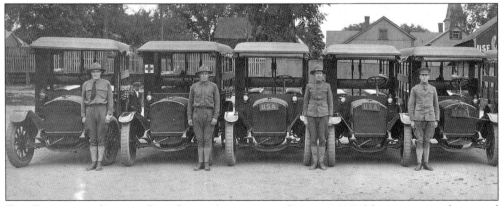

THE BERKSHIRE COUNTY RED CROSS AMBULANCE CORPS, 1917. Not everyone who served at the front was a soldier. Ambulance Company No. 13 of the Berkshire County Red Cross was formed in 1917 and was soon sent to Camp Devens in Ayer. There it became Ambulance Company No. 301. With 119 members and 12 ambulances, the company spend nearly a year at the front.

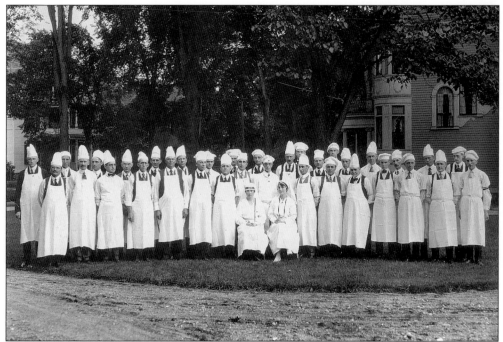

RED CROSS VOLUNTEERS, C. 1917. This dedicated group of volunteers prepared bandages and surgical dressings for the front.

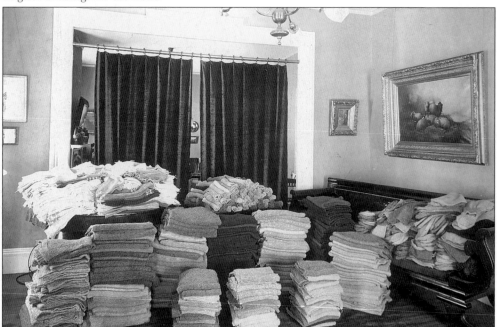

BLANKETS, C. 1917. The Pittsfield Sailor's Comfort Committee of the Navy League worked hard to provide comforts for those serving their country in Europe. The Pittsfield chapter was part of a statewide network that furnished knitted goods for soldiers, outfitted the young men of Pittsfield who were enlisting, and provided Christmas boxes from home for those serving overseas.

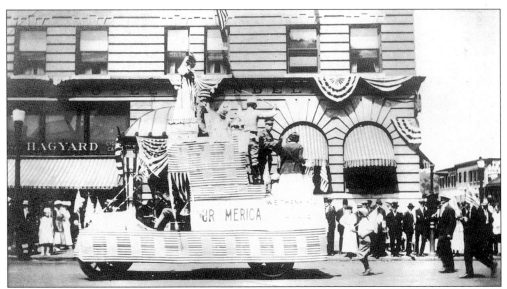

LIBERTY BOND PARADE, 1917. The Syrian community in Pittsfield provided this float. In 1912, a group of immigrants formed the Syrian-American Club, which was expanded to the Syrian-Lebanese-American Club in 1948.

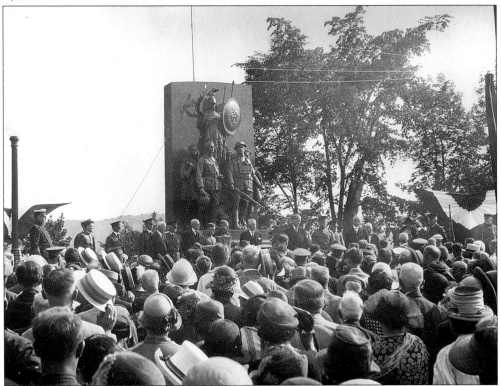

THE DEDICATION OF THE SOLDIERS' AND SAILORS' MEMORIAL, JULY 8, 1926. Designed by Augustus Lukeman, the memorial on South Street paid tribute to the men of Pittsfield who served during World War I, including Pittsfielder Col. Charles W. Whittelsey, commander of the famous "Lost Battalion," who received a Congressional Medal of Honor.

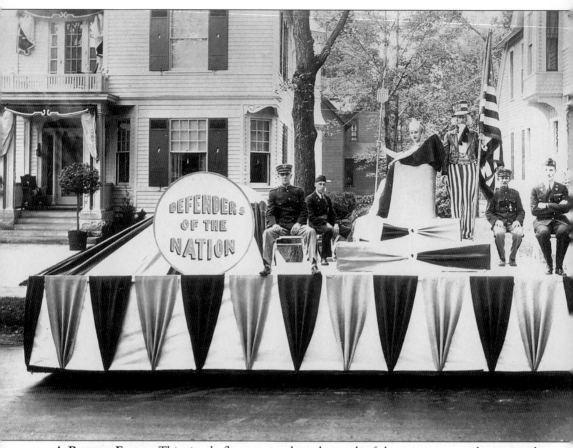

A Parade Float. This simple float summed up the work of the many men and women who had given their all and risked their lives during the conflicts that engulfed the world in the 20th century.

Six

PITTSFIELDERS AT PLAY

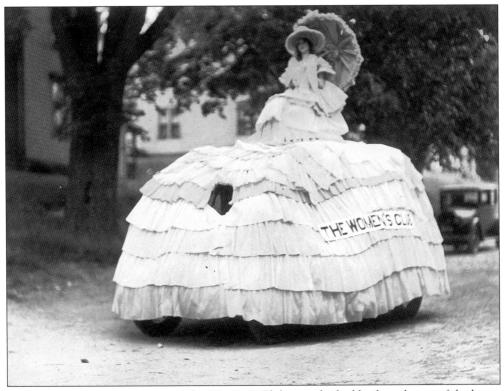

COLUMBUS DAY PARADE, 1914. The Women's Club entry looked back to the era of the hoop.

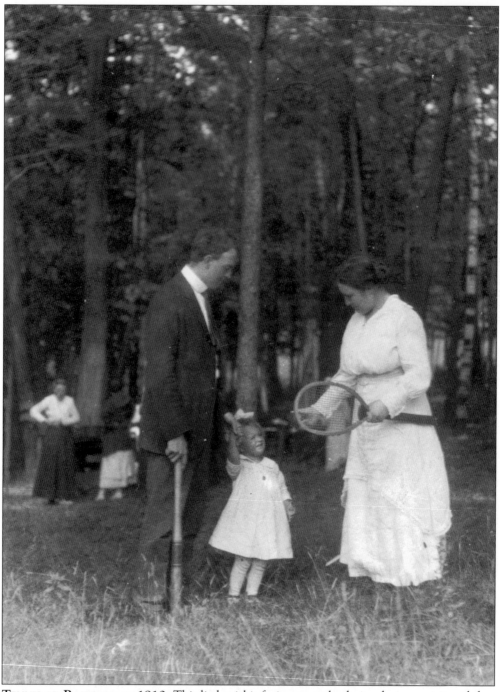

TENNIS OR BASEBALL, C. 1910. This little girl is facing an early choice during a visit with her parents to Berkshire Park. (Photograph by Laura Cowles.)

THE PITTSFIELD OUT-DOOR CLUB, 1881. Pittsfield had always supported a system of parks providing outdoor recreation. In the 1880s, Pleasure Park was created on Elm Street on the site of the old Civil War campground. The park was home to a clubhouse, racetrack, and baseball diamond. The racetrack was used first for horse racing and bicycle racing and then for automobile racing.

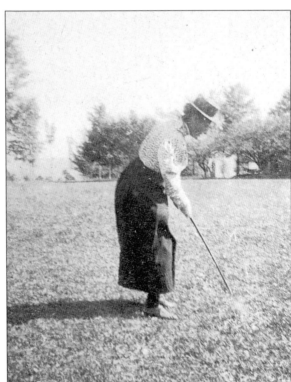

THE PITTSFIELD COUNTRY CLUB, 1900. In 1897, the Pittsfield Country Club established the first golf course in Pittsfield, a nine-hole course located between Dawes Avenue and Williams Street. The club moved to its South Street property in 1900.

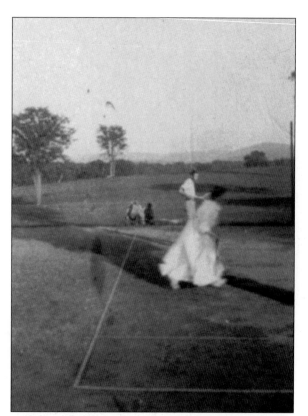

THE PITTSFIELD COUNTRY CLUB, 1903. The white apparition in the picture is a young woman apparently in her tennis dress. Yards of cotton lawn billowed in the wind as she played. Her doubles partner is equally well dressed in his vest and tie.

GIRLS' RACE, BERKSHIRE PARK, 1910. Berkshire Park was a favorite destination of Pittsfielders, with its scenic views and recreational facilities. (Photograph by Laura Cowles.)

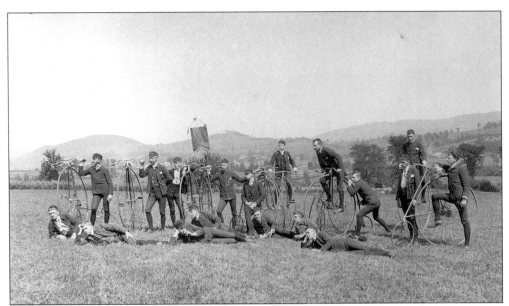

THE BERKSHIRE WHEELMEN, C. 1880. The Wheelmen were an amateur bicycle club made up of daring and colorful cyclists.

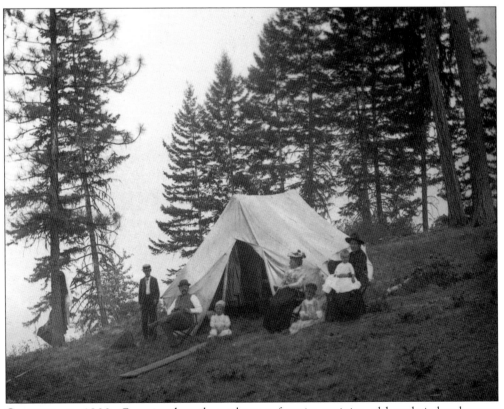

CAMPING, C. 1900. Camping has always been a favorite activity, although it has become less formal.

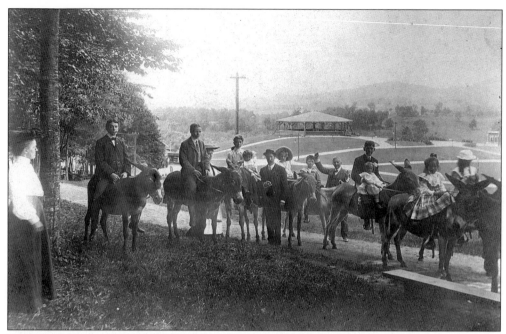

BERKSHIRE PARK, 1913. Judging by the number of photograph albums in the Berkshire County Historical Society collections and the numerous postcards featuring similar pictures, donkey rides were an extremely popular pastime for Pittsfielders. In almost all the photographs, the riders are rather elegantly dressed by today's standards. (Photograph by Laura Cowles.)

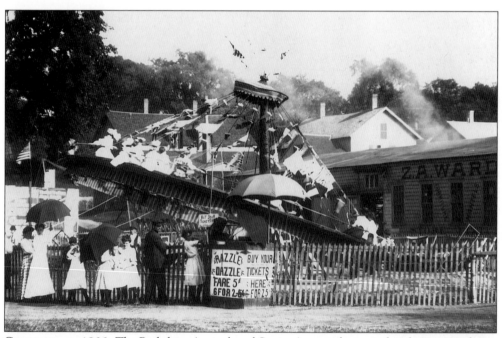

CARNIVAL, C. 1900. The Berkshire Agricultural Society's annual county fairs began a tradition that continued even after the fairs' demise. Traveling carnivals and circuses took place regularly, often at Wahconah Park.

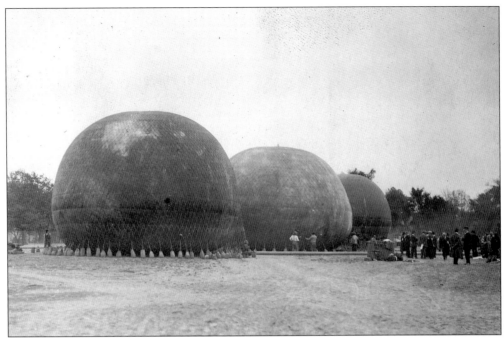

AERO PARK, OCTOBER 8, 1914. Although there had been balloon ascensions before in Pittsfield, Aero Park was not established until 1906. The Pittsfield Coal Gas Company provided the gas for the balloons, which often took sightseers into the air. In 1910, a nighttime excursion was arranged for viewing Halley's comet. (Photograph by Laura Cowles.)

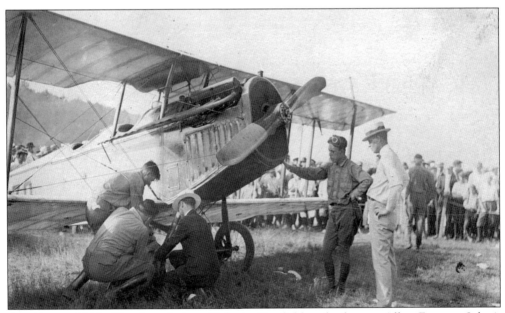

AIR SHOW, 1913. The first airplane flight in Pittsfield took place at Allen Farm on July 4, 1911, as part of the city's 150th anniversary celebration. The plane, piloted by Charles C. Witmer, crashed soon after takeoff, severely injuring Witmer. By the 1930s, air shows and flying were so popular that the *Eagle* had a regular column called "Aviation in the Berkshires."

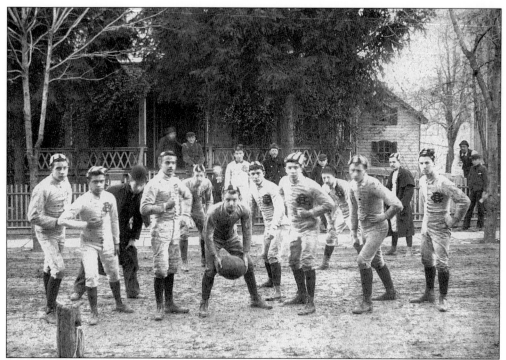

BERKSHIRE COUNTY FOOTBALL TEAM, 1889. The players included L.D. Kemp, A. Aguilar, E. Gonzalez, C. Brown, A. Gonzalez, R. Lavery, R. Robbins, A.H. Wood, J. Lavery, J. Jacoby, C. Annister, S.F. Vargas, and J. Renard.

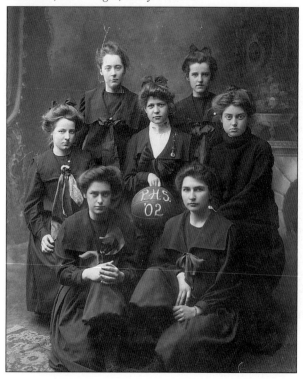

PITTSFIELD HIGH SCHOOL GIRLS' BASKETBALL TEAM, 1902. The young women of the basketball team pose for this formal portrait in their dark uniforms.

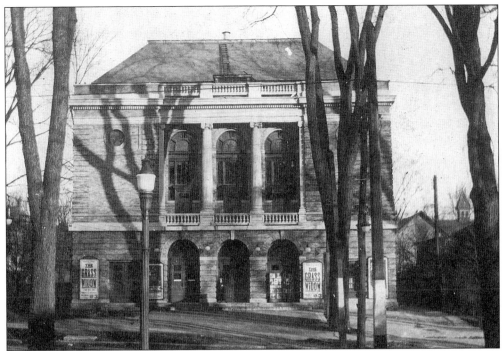

THE COLONIAL THEATER, C. 1915. Designed by Joseph McArthur Vance of Pittsfield and built in 1903, the Colonial was a magnificent venue for some of the finest theatrical productions in America. The likes of Sarah Bernhardt and the Barrymores performed there. The theater was converted to a movie house in 1938. The building still stands on South Street.

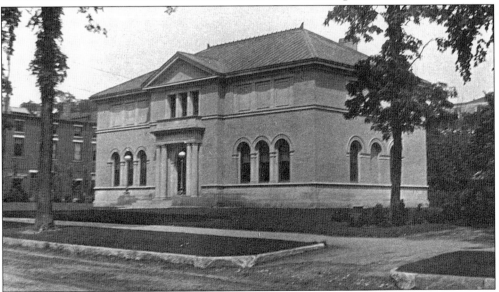

THE MUSEUM OF ART AND NATURAL HISTORY, 1903. Built in 1903 and designed by Pittsfield architect Henry Seaver, the museum was founded by Zenas Crane as a spin-off of the Berkshire Athenaeum. The Berkshire Athenaeum had become too crowded with its expanding collections to properly house its museum collections. Crane offered to fund a new building to house these collections, adding many additional items.

111

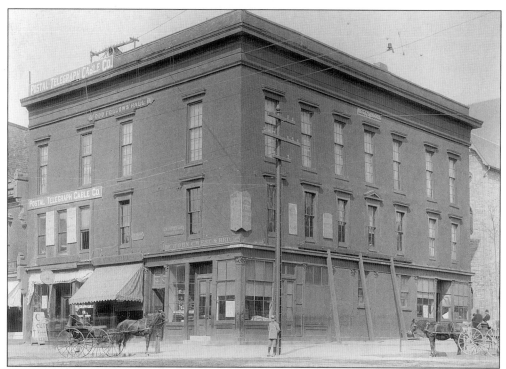

WEST'S BLOCK, 1853. John C. West built this building in 1850. The third floor contained the largest public space in Pittsfield at the time. West's Hall was the site for many musical evenings, plays, and other entertainments. Herman Melville wrote of taking his sons to the minstrel shows there. In 1860, the hall became the armory for the Pittsfield Guards.

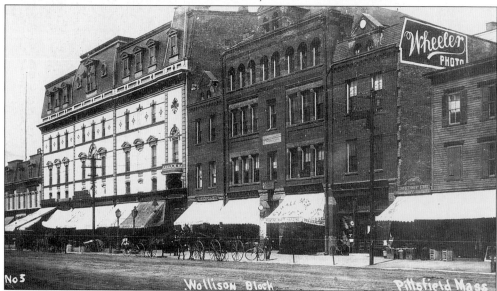

THE ACADEMY OF MUSIC, C. 1890. In 1872, the Academy of Music was built, replacing West's Hall as the principal cultural site in downtown Pittsfield. Located on North Street, it contained a 1,100-seat theater and a restaurant, the Palais Royal. It provided a venue for everything from opera to trained animal acts until 1903.

ACADEMY OF MUSIC, Pittsfield,

WEDNESDAY, SEPTEMBER 23, 1885

✦ SEATS NOW ON SALE AT USUAL PLACE. ✦

CHARLES H. CLARK'S GRAND REVIVAL

—— OF THE ——

Greatest Moral Temperance Drama of the Age,

✦ T. S. ARTHUR'S TEMPERANCE STORY, ✦

IN FIVE ACTS,

TEN NIGHTS IN A BAR ROOM

Received everywhere with Abundant and Rapturous demonstrations of Delight and Acknowledgements of Superiority.

LITTLE MARY'S APPEAL — "FATHER, COME HOME."

"YOU'VE HAD ENOUGH!"

A CORRECT PICTURE OF INTEMPERANCE.

A Play which has everywhere proven a sensation unparalleled in the history of the Drama.

THE SOBS AND TEARS OF SYMPATHY

from auditors of all sexes and ages, who come to witness this truthful picture, are evidences of its wonderful dramatic power. Over 100,000 persons heads of families, members of churches, all interested in the propagation of the great principles of Temperance, have borne testimony to the

Life-like Delineation of Folly, Misery, Madness, and Crime,

caused by the brutal, disgusting and demoralizing vice of Drunkenness.

☞ This beautiful Drama depicts a series of truthful scenes in the course of a Drunkard's Life. Some of them are touching in the extreme, and some are dark and terrible. Step by step is portrayed the downward course of the tempting vender and his infatuated victim, until both are involved in hopeless ruin. The play is marred by no exaggerations, but exhibits the actualities of Life, with a severe simplicity and adherance to truth that gives to every picture a photographic vividness. The large audiences seem to be in full sympathy with the moral of the story, and **Laugh at Gilpin Gawk, Sympathize with poor drunken Joe Morgan, and weep at the**

DEATH OF LITTLE MARY.

A BROADSIDE FOR A PERFORMANCE AT THE ACADEMY OF MUSIC, 1885. The temperance movement was strong in Pittsfield, and the town boasted several temperance societies. The Father Mathew Total Abstinence Society was perhaps the longest lived, lasting until 1955.

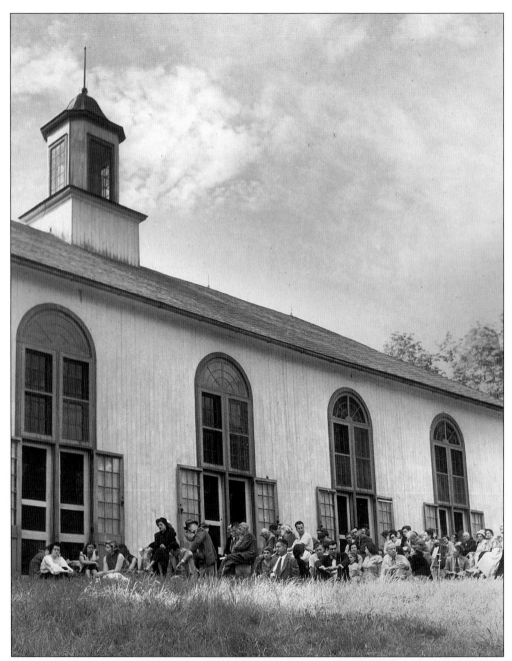

SOUTH MOUNTAIN CONCERTS, C. 1940. Elizabeth Sprague Coolidge moved to Pittsfield in 1904. A composer herself, she was particularly fond of chamber music and often invited musicians to perform at her home. In 1918, Mrs. Coolidge built a summer home, a concert hall, and several cottages to house musicians on the South Mountain property she had purchased for her son, beginning a Pittsfield tradition of summer chamber music concerts. (Photograph by Clemens Kalischer.)

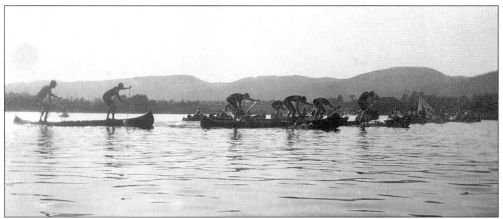

YMCA Aquatic Meet, September 10, 1904. In 1904, the YMCA established a summer camp, Camp Merrill, on the shores of Pontoosuc and built the Ponterril Boat House there. Aquatic meets included competitions in swimming, boat racing, and tilting.

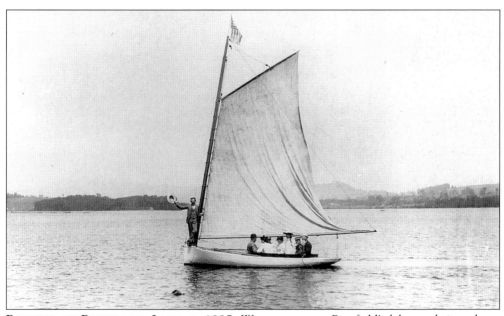

Boating on Pontoosuc Lake, c. 1895. Water sports on Pittsfield's lakes and rivers have always been popular. Pontoosuc Lake has hosted many sailboats from which sailors can enjoy the magnificent views of the mountains. (Photograph by S.S. Wheeler.)

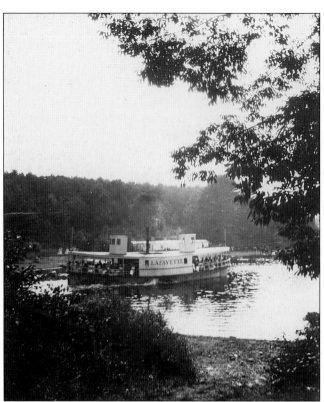

THE LAFAYETTE, C. 1900.
The Lafayette was a fixture on Pontoosuc Lake for 22 years. Built by a Frenchman, Peter Hodecker, the two-deck boat could hold up to 300 people who took on sightseeing tours around the beautiful lake. In 1911, Hodecker dismantled the boat and used the wood to build cottages on the shore.

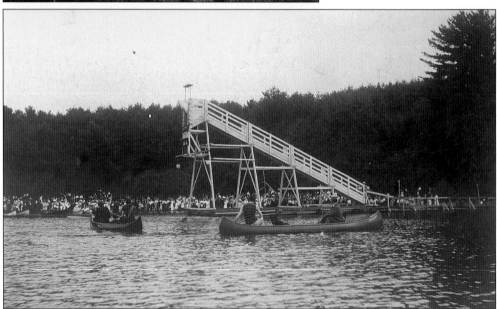

PONTOOSUC LAKE, 1909. Pontoosuc Lake was also the site of exhibitions by J.W. Gorman's High Diving Horses. Gorman said that his first horse, King, came to diving naturally when he was once separated from his mother by a stream and dove off the high bank into the water in order to reunite with her. Here, Queen has climbed to the top of the ramp and is waiting for the signal to dive.

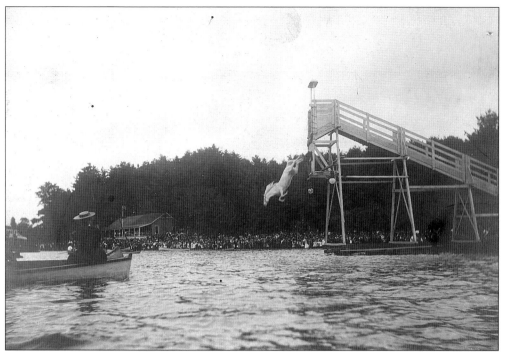

THE DIVE, 1909. Much to the delight of the hundreds of people in the crowd, Queen leaps gracefully into the water.

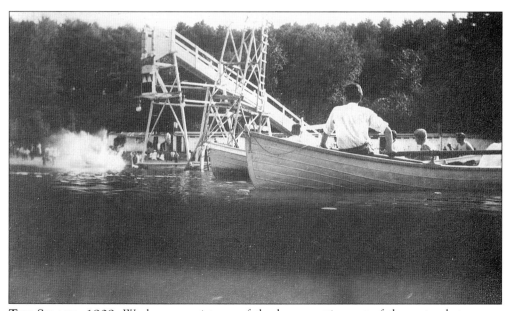

THE SPLASH, 1909. We have no pictures of the horse getting out of the water, but we are assured that Queen dived safely again and again. We do not know how Queen came to learn to dive.

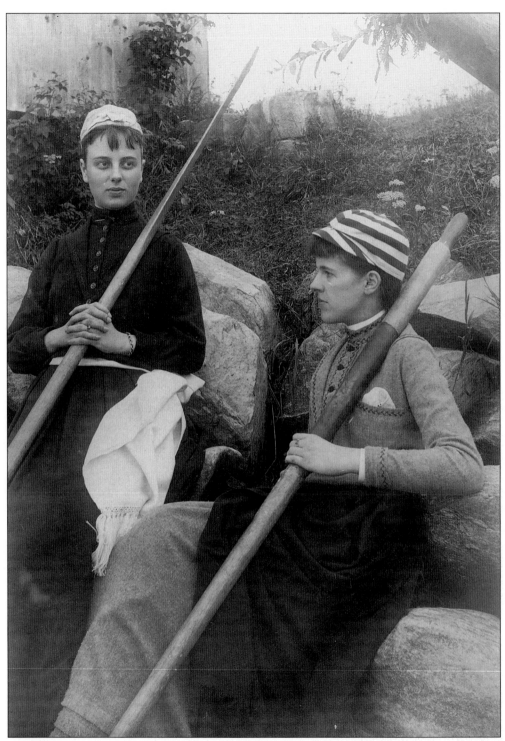

THE ROWERS, C. 1880. This lovely portrait shows two young women dressed in the latest sports attire for the 1880s. Women wore tight corsets and long skirts no matter what the form of exercise.

ELIZABETH JACKSON, C. 1867. Winter sports have always been popular as well. Here, a young woman poses for a formal portrait in her skating attire.

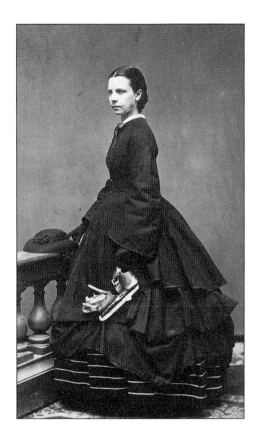

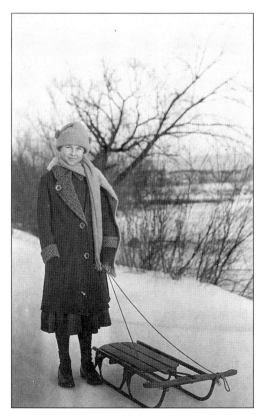

GIRL WITH SLED, C. 1910. Pittsfield's children lost a favorite spot for sledding when the knoll on East Street, where the Plunkett House stood, was graded to make way for the new high school in 1932. (Photograph by Laura Cowles.)

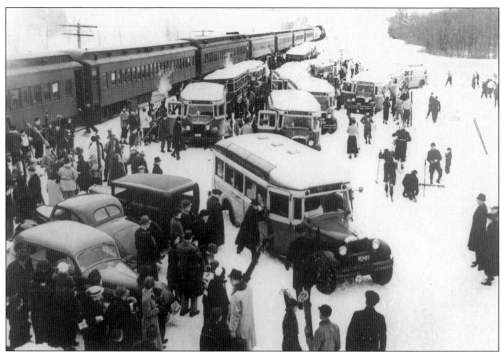

SNOW TRAIN, C. 1940. In 1935, the New Haven railroad began to operate special "snow trains" on weekends. Often running nonstop from New York City to Pittsfield, the trains carried thousands of city dwellers anxious for a weekend on the slopes.

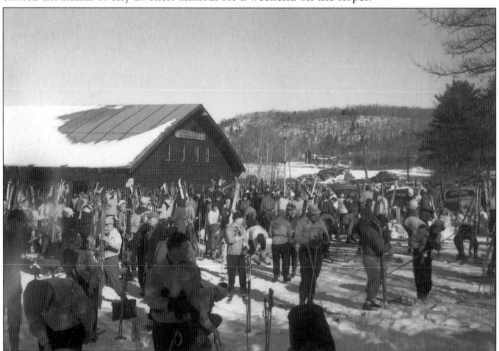

BOSQUET, C. 1945. Bosquet opened in 1935 and soon made history as the first commercial snow maker in the world. (Photograph by Arthur Palme.)

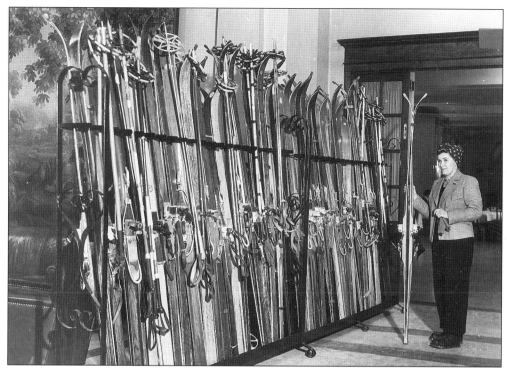

The Wendell Hotel, c. 1945. The Wendell Hotel had its own ski check for the thousands of skiers who stayed there during these weekend jaunts. Pictured is Grete Haitinger of New York and Vienna. (Photograph by Arthur Palme.)

Bosquet, c. 1945. Bosquet was also known for being the site of the first lighted night skiing in the world. With help from employees at General Electric and the Pittsfield Electric Company, the lights were lit on December 24, 1936. (Photograph by Arthur Palme.)

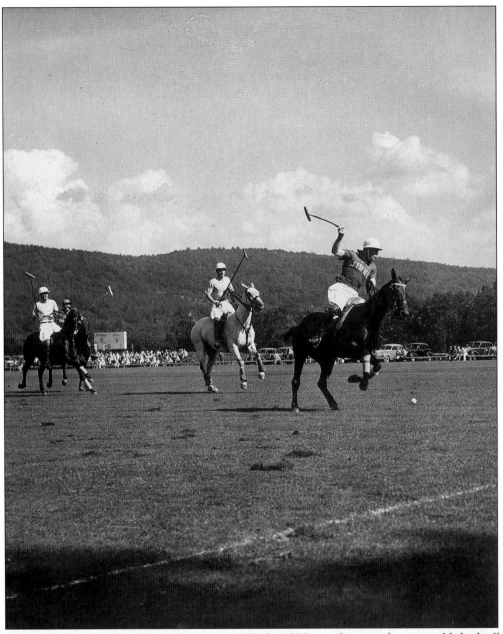

PITTSFIELD RIDING AND POLO CLUB, C. 1955. In 1930, a polo grounds was established off Holmes Road. Matches with teams throughout the region took place for 30 years. (Photograph by Howard S. Babbitt Jr.)

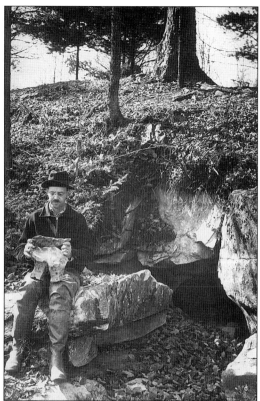

GREAT RADIUM SPRINGS CAVE, 1940s.
The cave was a popular destination for
avid spelunkers, including photographer
Arthur Palme, who took these
photographs of Clay Perry, author of a
book on New England caves. Located in
the western part of Pittsfield, it was the
third longest cave in New England. Its
owner filled in the cave in 1976. An
expert on caves and caving, Perry also
wrote a column for the *Eagle* and
published numerous articles in his book.
Underground New England was published
in 1938.

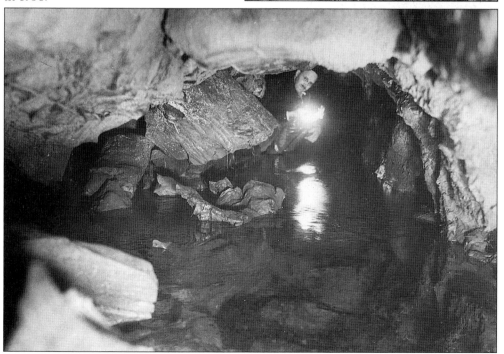

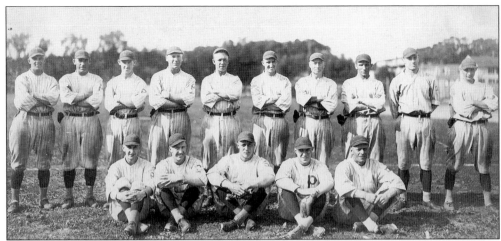

THE PITTSFIELD HILLIES, 1921. Pittsfield has a long tradition of baseball. The Pittsfield Hillies, a Class A professional team, won the Eastern League pennant in 1919 and again in 1921.

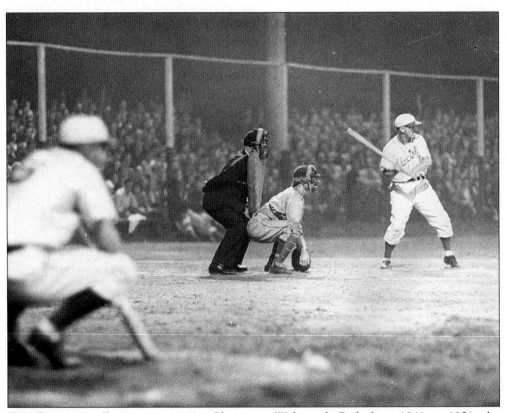

THE PITTSFIELD ELECTRICS, 1940s. Playing at Wahconah Park from 1941 to 1951, the Electrics of the Canadian-American League were Pittsfield's team. (Photograph by Howards S. Babbitt Jr.)

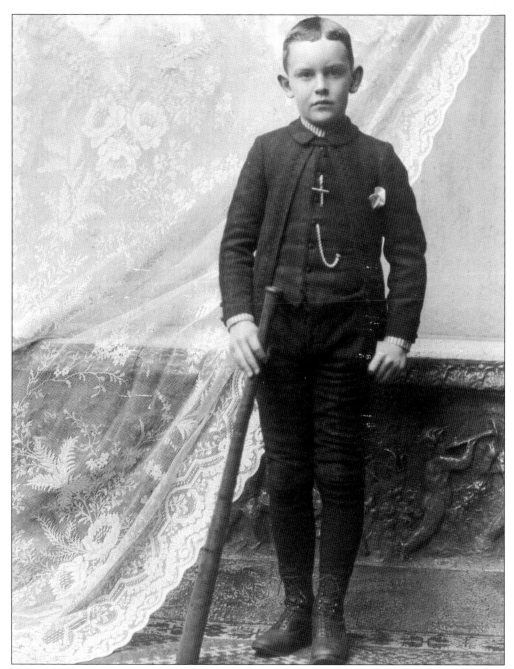

BOY WITH BAT, C. 1890. Baseball seems to have always been a part of life in Pittsfield. This boy was such a fan that he chose to include his bat in his formal portrait. The first intercollegiate baseball game in the United States (between Williams College and Amherst) was played in Pittsfield in 1859. The town hosted professional baseball as early as 1894. In an interesting bylaw, written after the construction of the Second Meeting House in 1793, the town forbade the playing of "wicket, cricket, base-ball, bat-ball, foot-ball, cats, fives, or any other game played with ball" within 80 yards of the church. Just what "base-ball" and "bat-ball" were in the 18th century is unclear. (Photograph by S.S. Wheeler.)

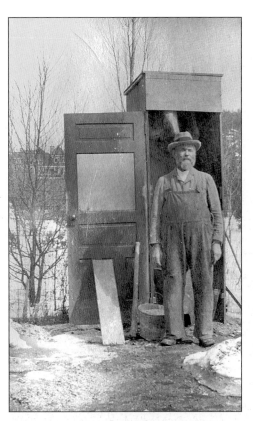

AMERICAN OUTHOUSE GOTHIC, C. 1910.
This family's sense of humor shines through in a series of photographs, two of which are shown here. This unidentified family was apparently very proud of their new facilities, for each member of the clan had their picture taken with the new addition. Sometimes the long, cold winters are a little too long.

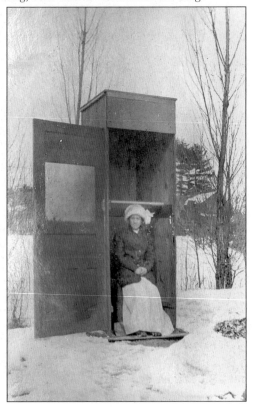

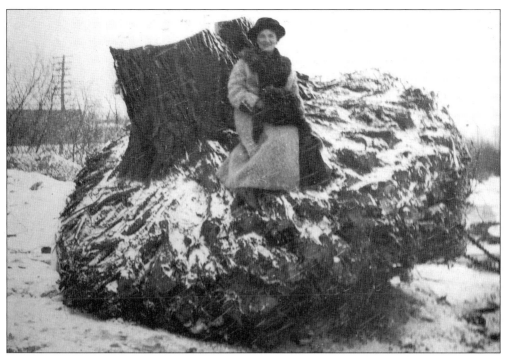

THE GIANT STUMP, 1914. Then there's always a visit to a giant stump.

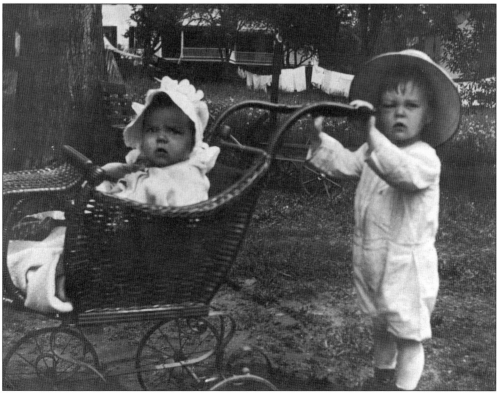

SIBLINGS, 1913. There's also quality time with family. (Photograph by Laura Cowles.)

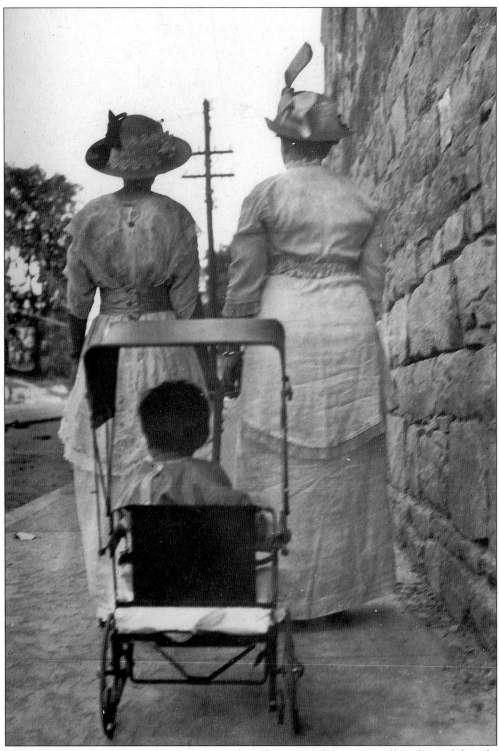

TAKING A WALK, AUGUST 26, 1914. Nothing beats an afternoon stroll with good friends. (Photograph by Laura Cowles.)